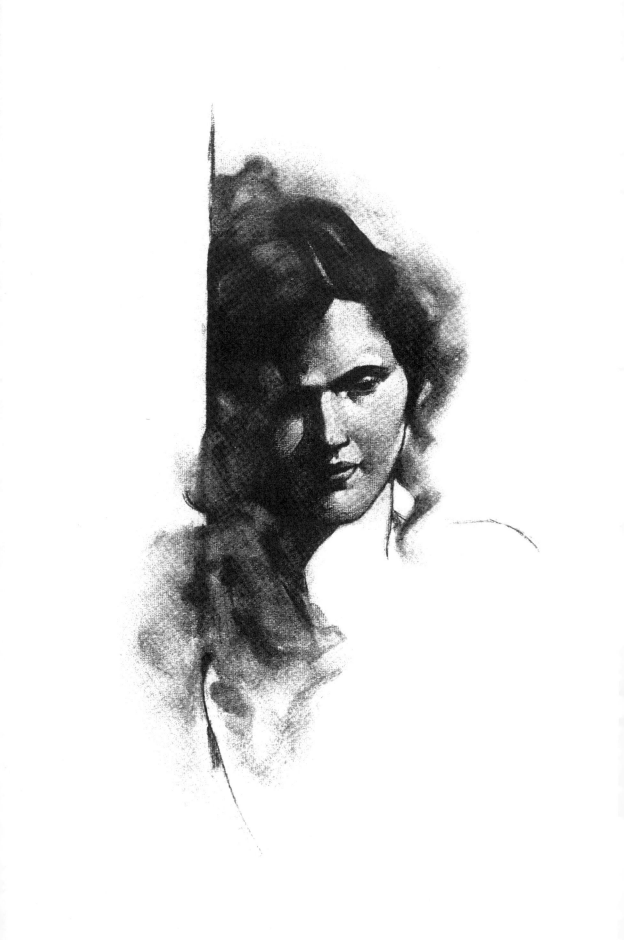

FASHION
ILLUSTRATION
1920-1950

TECHNIQUES AND EXAMPLES

WALTER T. FOSTER

DOVER PUBLICATIONS, INC.
MINEOLA, NEW YORK

Bibliographical Note

This Dover edition, first published in 2010, is an unabridged republication of the books *How to Draw the Figure: Female Fashions,* originally published by Walter T. Foster Publishing, Palms, California, 1930; *How to Draw the Figure: Female Fashion* (Walter T. Foster, Hollywood, California, n.d.); *How to Draw the Figure: Male Fashion* (Walter T. Foster, Laguna Beach, California, n.d.); and *How to Draw the Figure: Male Fashion* (Walter T. Foster, Palms, California, 1930).

Library of Congress Cataloging-in-Publication Data

Foster, Walter T. (Walter Thomas), 1891–1981.
 Fashion illustration, 1920–1950 : techniques and examples / Walter T. Foster. —Dover ed.
 p. cm.
 "An unabridged republication of the books How to Draw the Figure: Female Fashions, originally published by Walter T. Foster Publishing, Palms, California, 1930; How to Draw the Figure: Female Fashion (Walter T. Foster, Hollywood, California, n.d.); How to Draw the Figure: Male Fashion (Walter T. Foster, Laguna Beach, California, n.d.); and How to Draw the Figure: Male Fashion (Walter T. Foster, Palms, California, 1930)."
 ISBN-13: 978-0-486-47471-7
 ISBN-10: 0-486-47471-2
 1. Fashion Drawing. I. Title.

TT509.F577 2009
 741.6'72—dc22

2009029289

Manufactured in the United States by Courier Corporation
47471201
www.doverpublications.com

FASHION
ILLUSTRATION
1920-1950

TECHNIQUES AND EXAMPLES

How to Draw the Figure: Female Fashions
Part I

DIRECTIONS

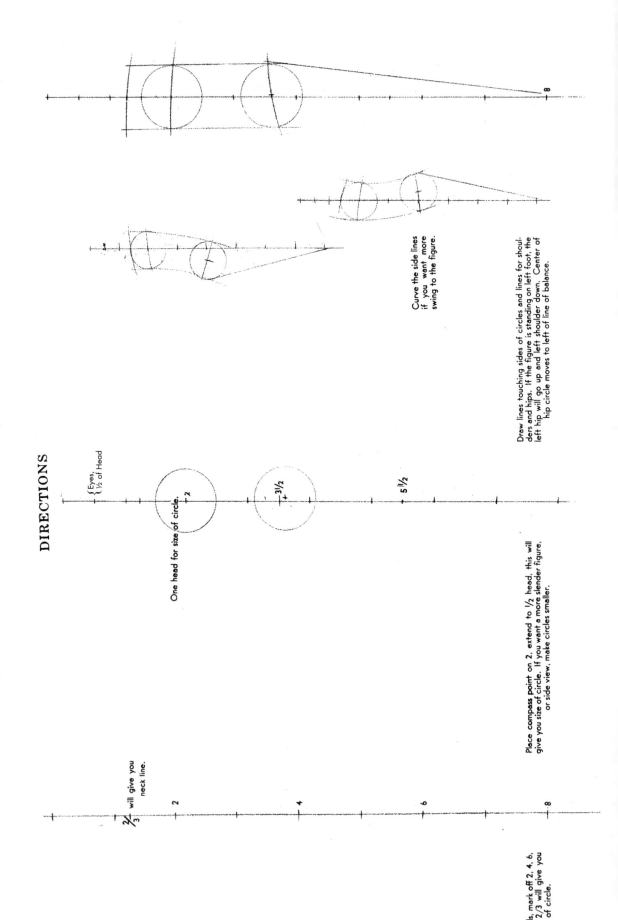

{ Eyes, ½ of Head

One head for size of circle.

2

3½

5½

⅔ will give you neck line.

2

4

6

8

Curve the side lines if you want more swing to the figure.

Draw lines touching sides of circles and lines for shoulders and hips. If the figure is standing on left foot, the left hip will go up and left shoulder down. Center of hip circle moves to left of line of balance.

Place compass point on 2, extend to ½ head, this will give you size of circle. If you want a more slender figure, or side view, make circles smaller.

Draw vertical line, divide in eight heads, mark off 2, 4, 6, 8, divide the second head in thirds. 2/3 will give you neck line. One head for size of circle.

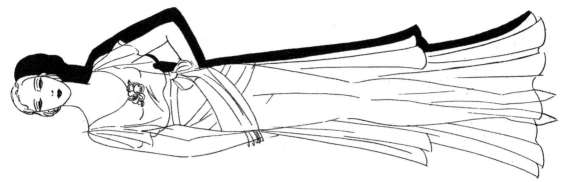

When you are making long lines as shown in the leg, arm or body line, always turn your paper so you can use muscular movement. Practice inking in these drawings through tissues. When making drawings, it is best not to tack them to the board. Note the freedom of line.

Center of neck and center of ankle will always be on the line of balance (or vertical line) unless figure is standing on both feet or in action. This figure was made with 170 pen point and the black added with No. 3 brush.

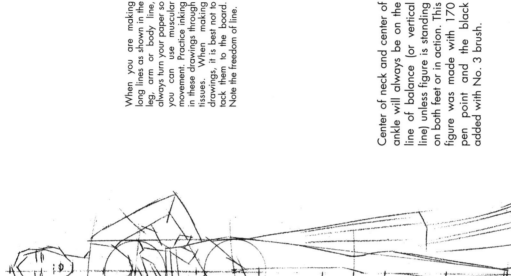

Draw leaf shape for hands, divide in middle, giving length of fingers. Do not draw in fingers until you have them in the position you want them. Drape garment over circles and proceed with the inking in.

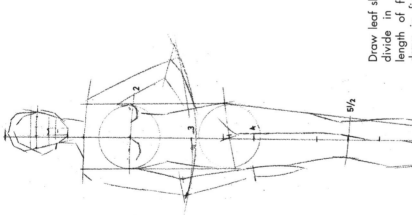

I show straight ruled lines and circles made with a compass to impress the simplicity of thinking in straight lines and circles, for mental measurements. When drawing figure, I suggest the line of balance, check heads, think of the size circles to go with the figure. (See directions for "How to Draw the Figure: Male Fashion," Part 1, page 78.)

Draw waistline connecting circles, then hips, add neck and shoulders, then head. You should not start shading or inking in until you have completed the blocking in. Try to keep your drawing simple, erase all extra lines. Do not draw with scratchy lines.

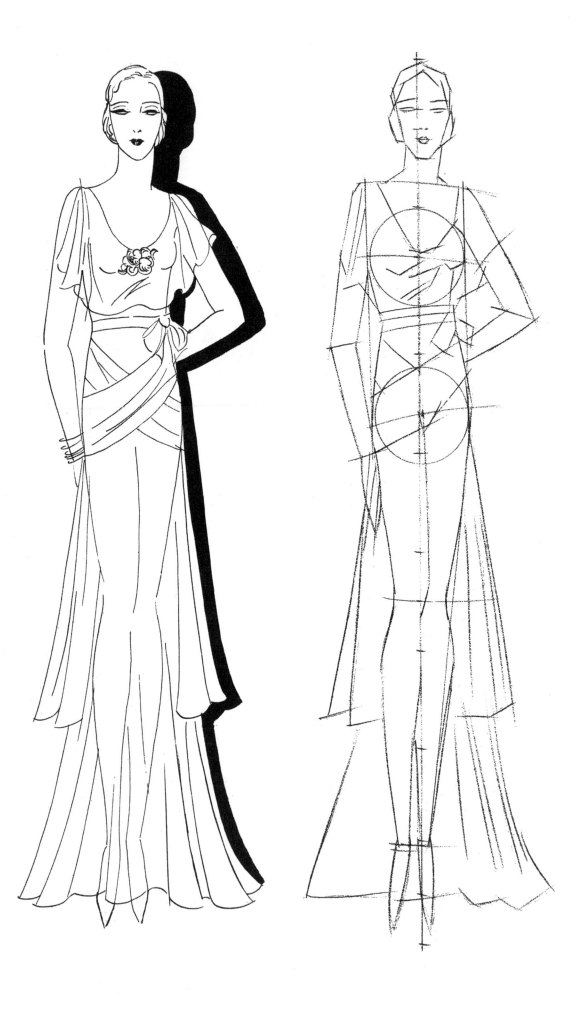

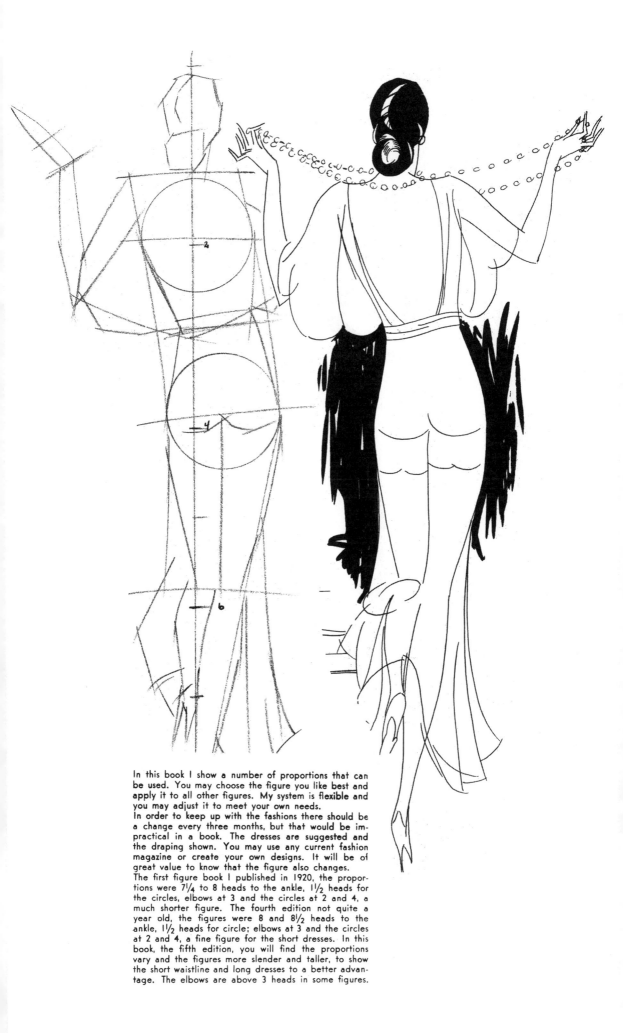

In this book I show a number of proportions that can
be used. You may choose the figure you like best and
apply it to all other figures. My system is flexible and
you may adjust it to meet your own needs.

In order to keep up with the fashions there should be
a change every three months, but that would be im-
practical in a book. The dresses are suggested and
the draping shown. You may use any current fashion
magazine or create your own designs. It will be of
great value to know that the figure also changes.

The first figure book I published in 1920, the propor-
tions were 7¼ to 8 heads to the ankle, 1½ heads for
the circles, elbows at 3 and the circles at 2 and 4, a
much shorter figure. The fourth edition not quite a
year old, the figures were 8 and 8½ heads to the
ankle, 1½ heads for circle; elbows at 3 and the circles
at 2 and 4, a fine figure for the short dresses. In this
book, the fifth edition, you will find the proportions
vary and the figures more slender and taller, to show
the short waistline and long dresses to a better advan-
tage. The elbows are above 3 heads in some figures.

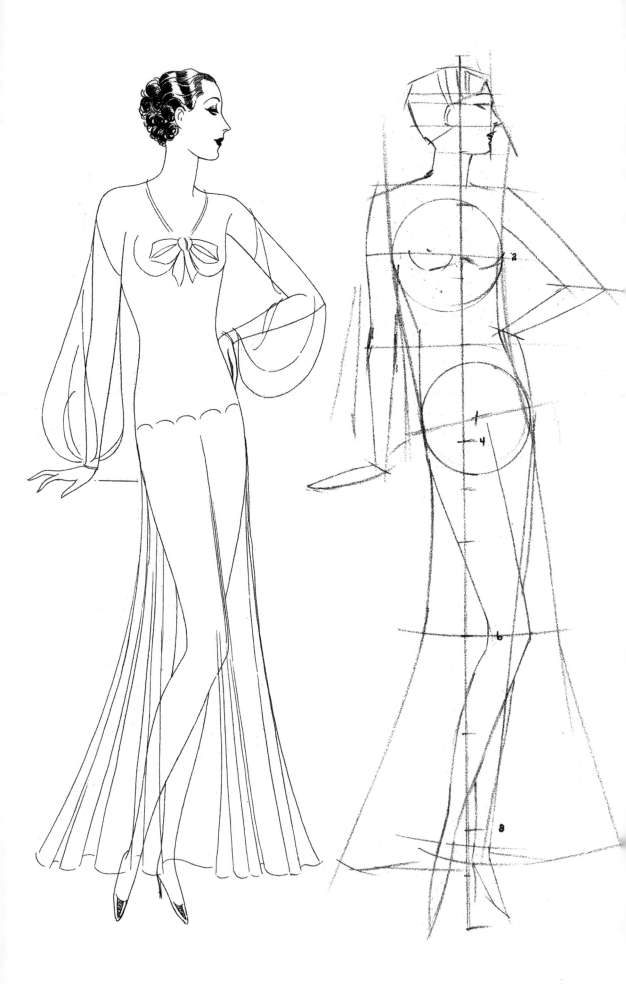

See Direction Sheet

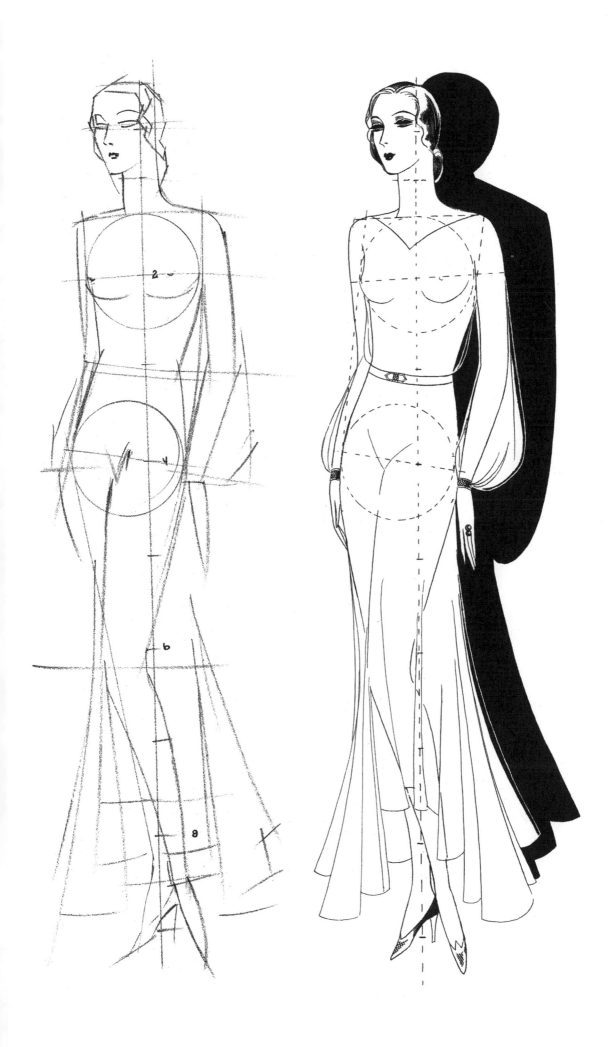

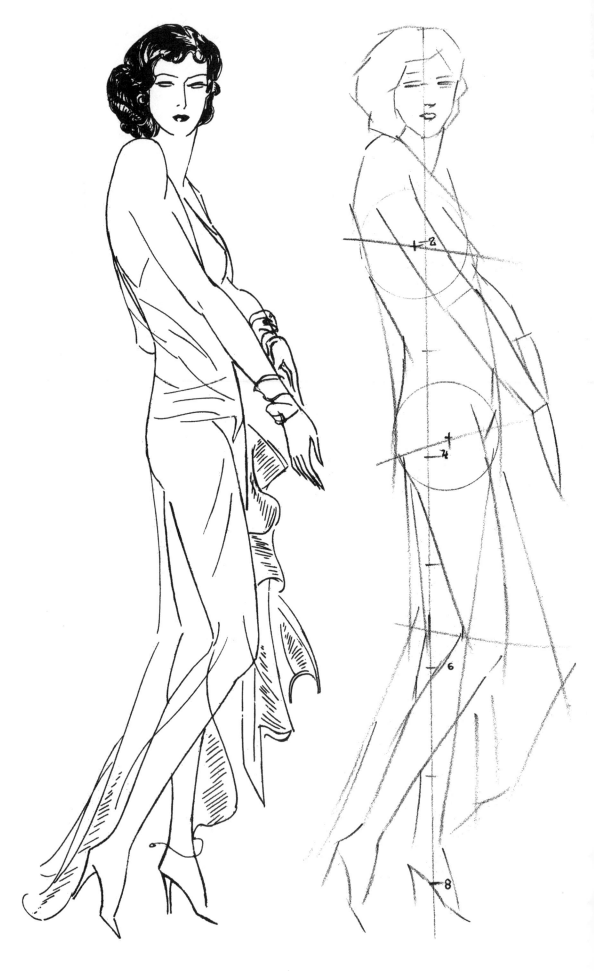

See Direction Sheet

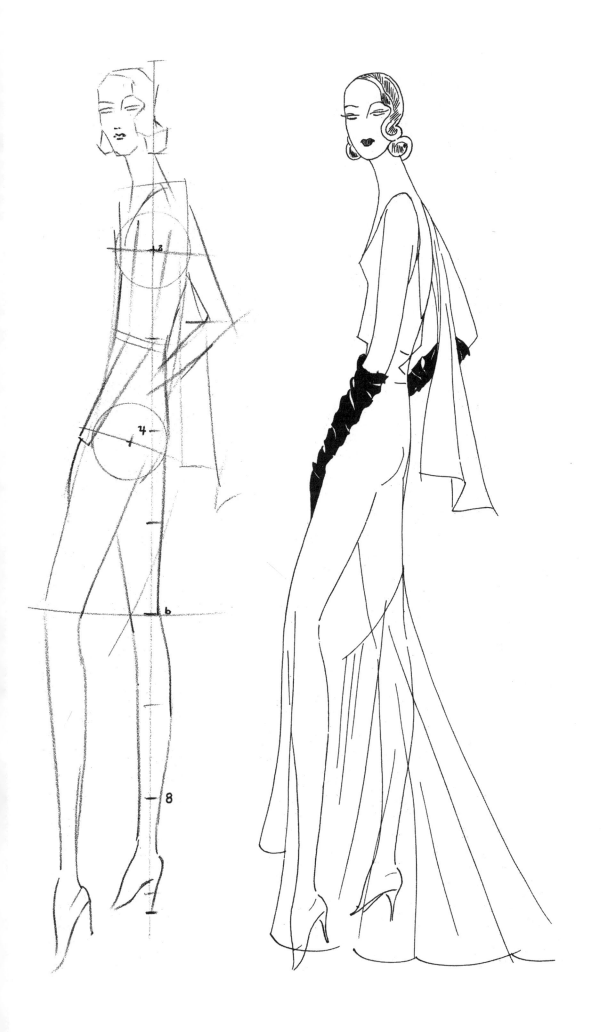

Silks —

Your Name

When you are making long lines as shown in the leg, arm or body line, always turn your paper so you can use muscular movement. Practice inking in these drawings through tissues. When making drawing, it is best not to tack them to the board. Note the freedom of line in the designs, this is made with a free arm movement.

New Fabrics

Your Name

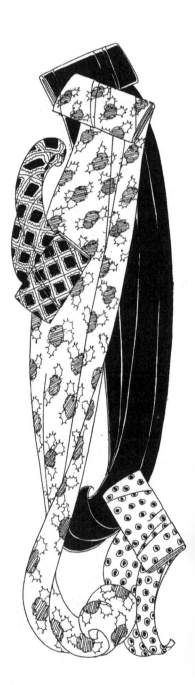

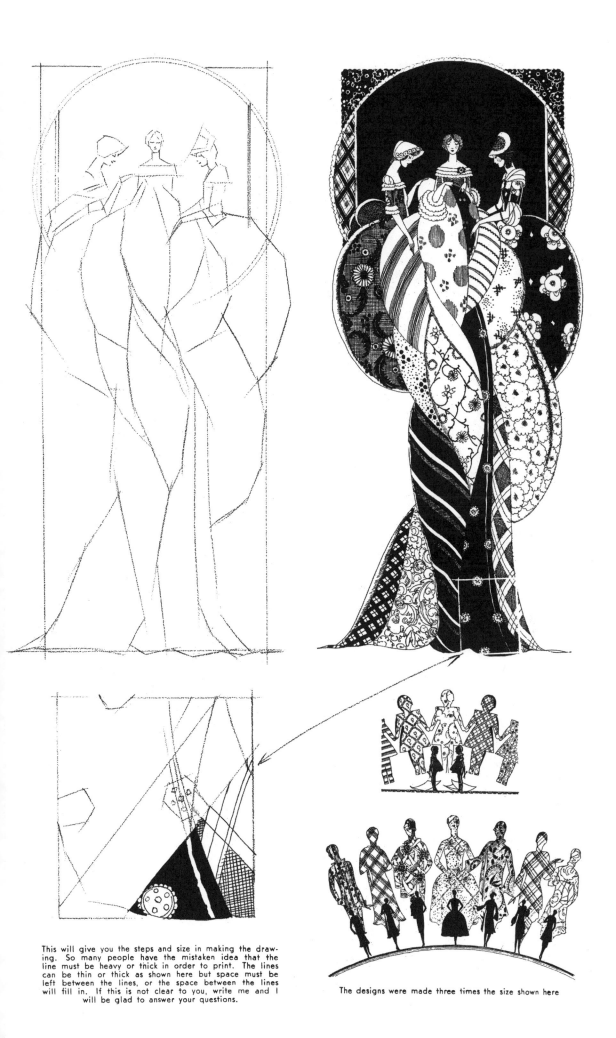

This will give you the steps and size in making the drawing. So many people have the mistaken idea that the line must be heavy or thick in order to print. The lines can be thin or thick as shown here but space must be left between the lines, or the space between the lines will fill in. If this is not clear to you, write me and I will be glad to answer your questions.

The designs were made three times the size shown here

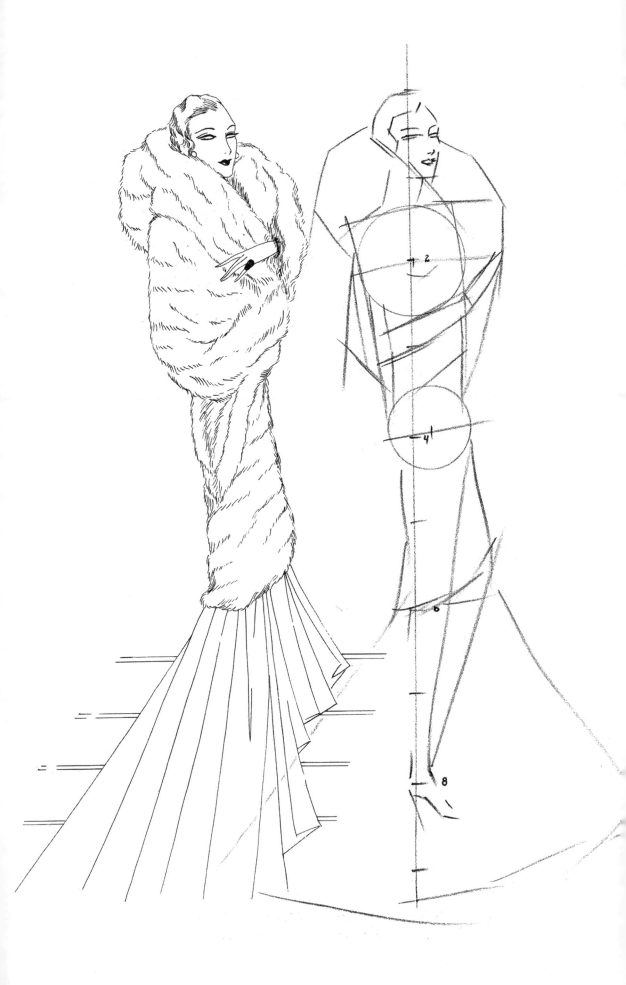

See Direction Sheet

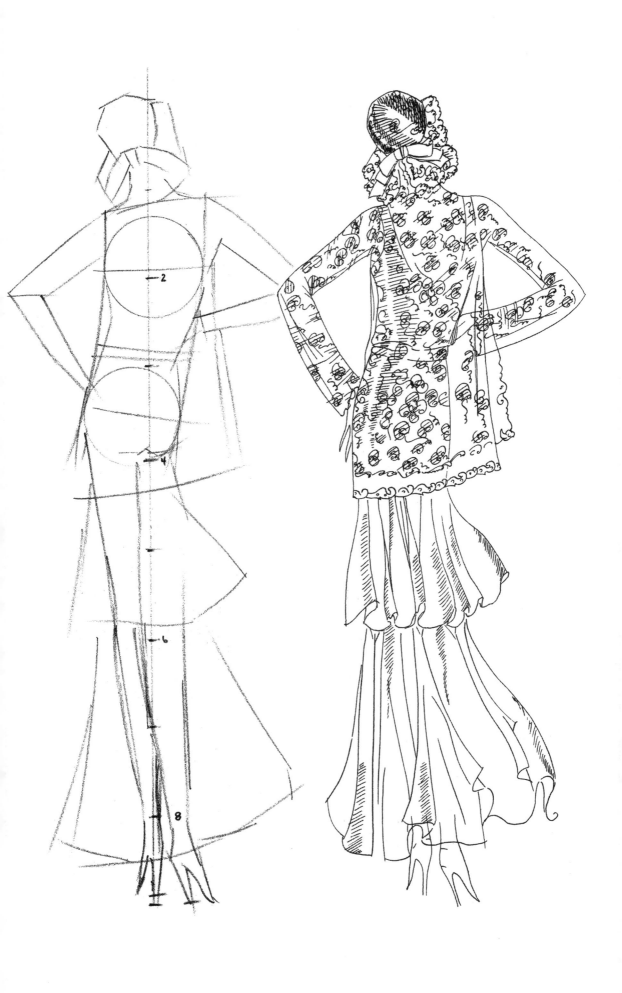

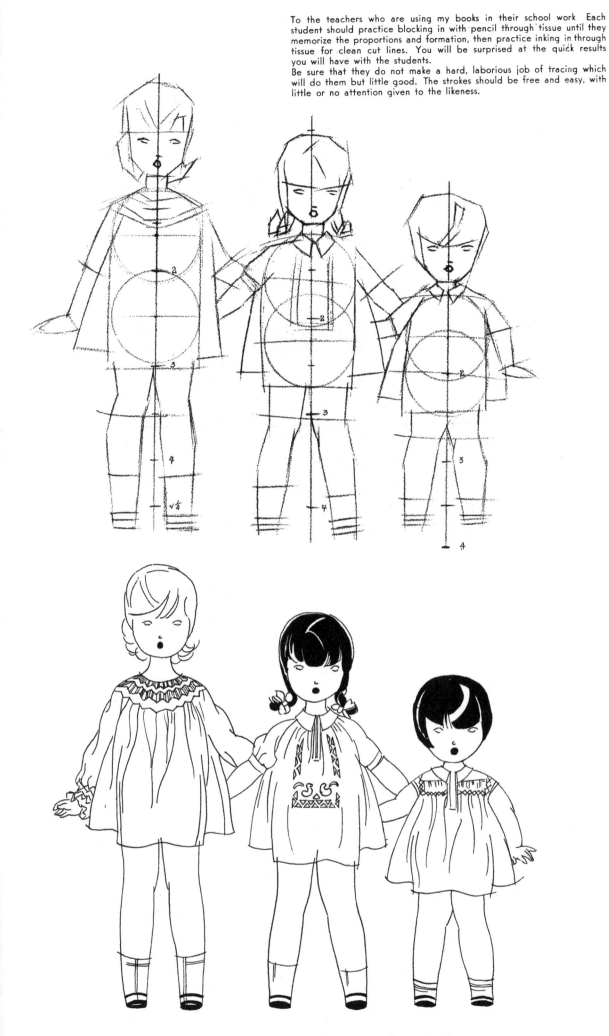

To the teachers who are using my books in their school work. Each student should practice blocking in with pencil through tissue until they memorize the proportions and formation, then practice inking in through tissue for clean cut lines. You will be surprised at the quick results you will have with the students.

Be sure that they do not make a hard, laborious job of tracing which will do them but little good. The strokes should be free and easy, with little or no attention given to the likeness.

This type of figure is quite easy to make and very effective in advertising or for designing children's dresses.

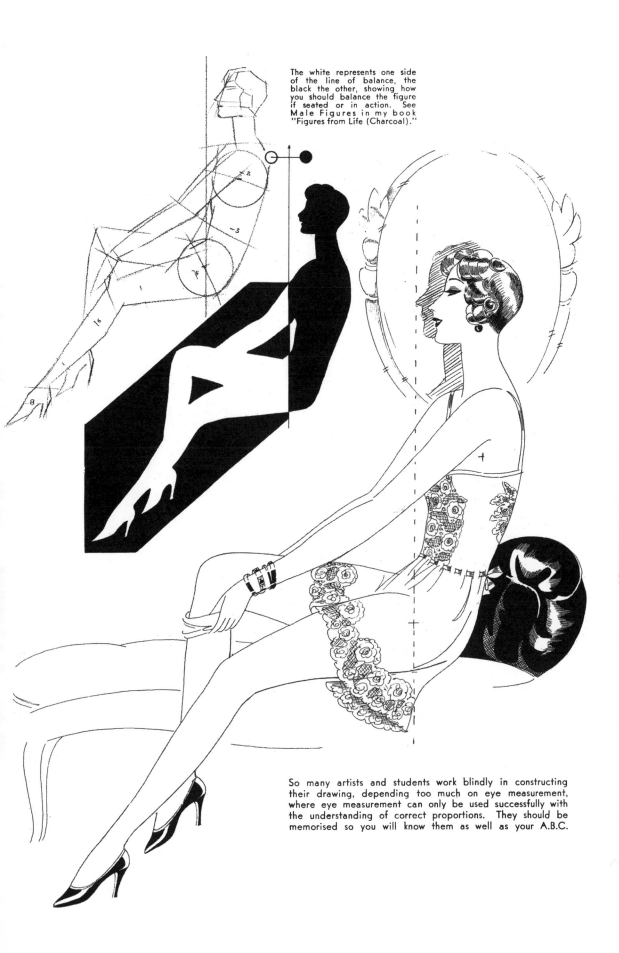

The white represents one side of the line of balance, the black the other, showing how you should balance the figure if seated or in action. See Male Figures in my book "Figures from Life (Charcoal)."

So many artists and students work blindly in constructing their drawing, depending too much on eye measurement, where eye measurement can only be used successfully with the understanding of correct proportions. They should be memorised so you will know them as well as your A.B.C.

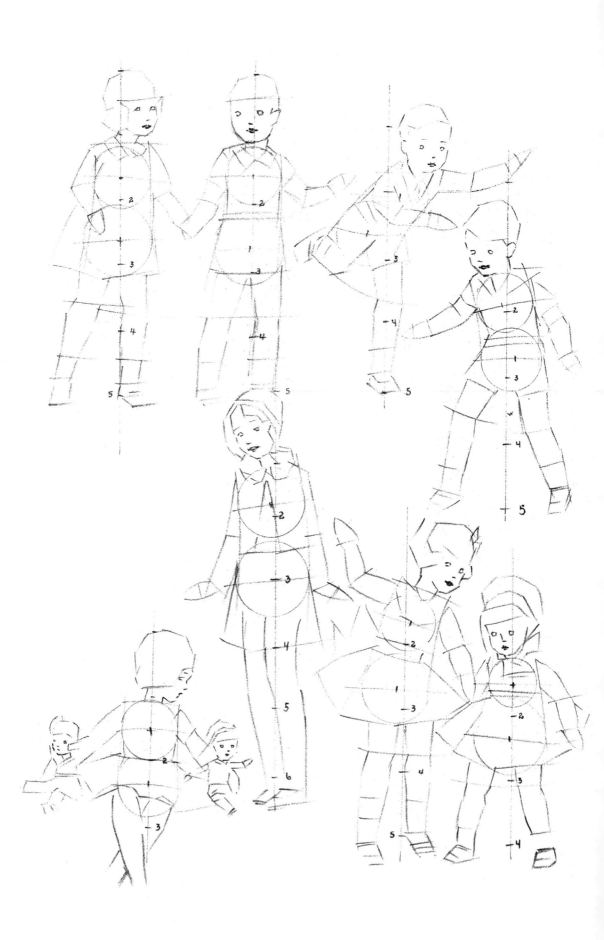

16

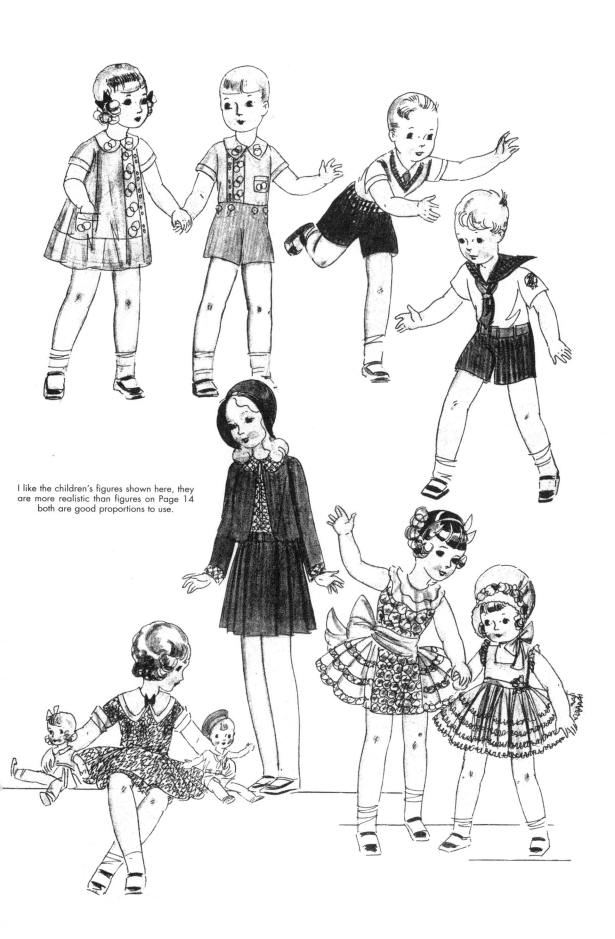

I like the children's figures shown here, they are more realistic than figures on Page 14 both are good proportions to use.

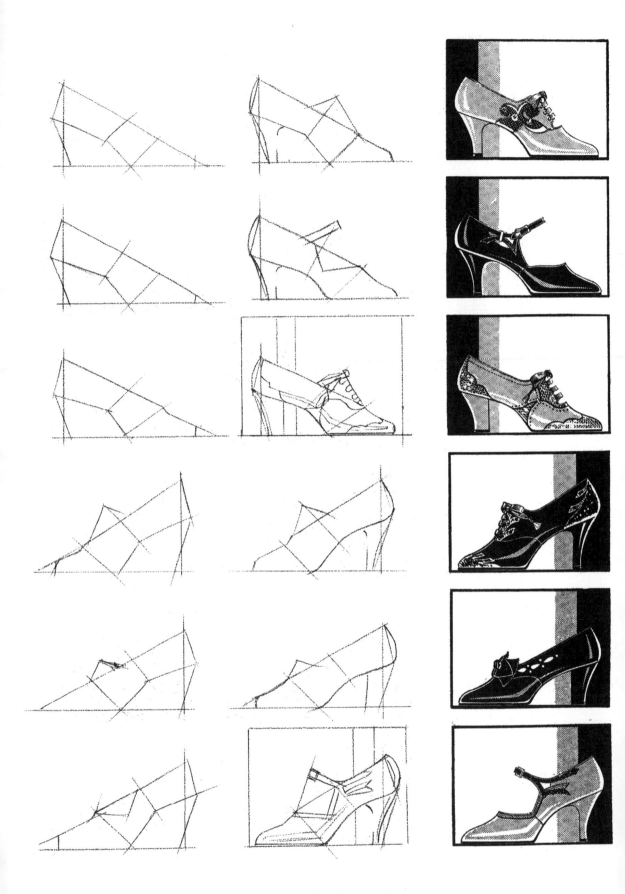

The Back of the heel extends to or in front of line of balance. If placed too far forward it will look like a shoe that has been worn for some time. So many artists make this mistake in drawing feet. Drawings made to sell shoes are drawn two or three times the size of the ones shown here, and the artist uses a ruling pen and a french curve to get the smooth lines.

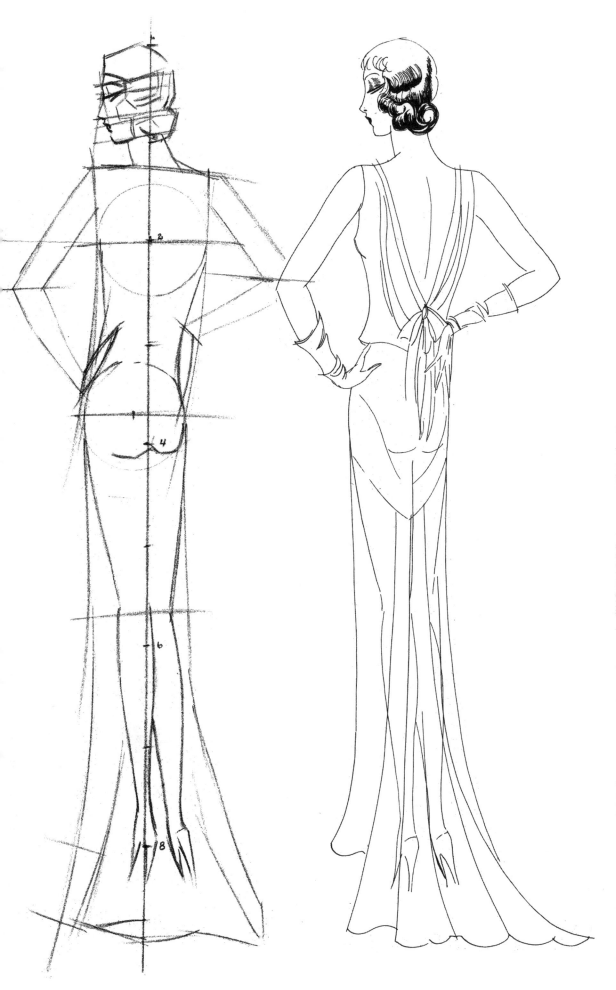

See Direction Sheet

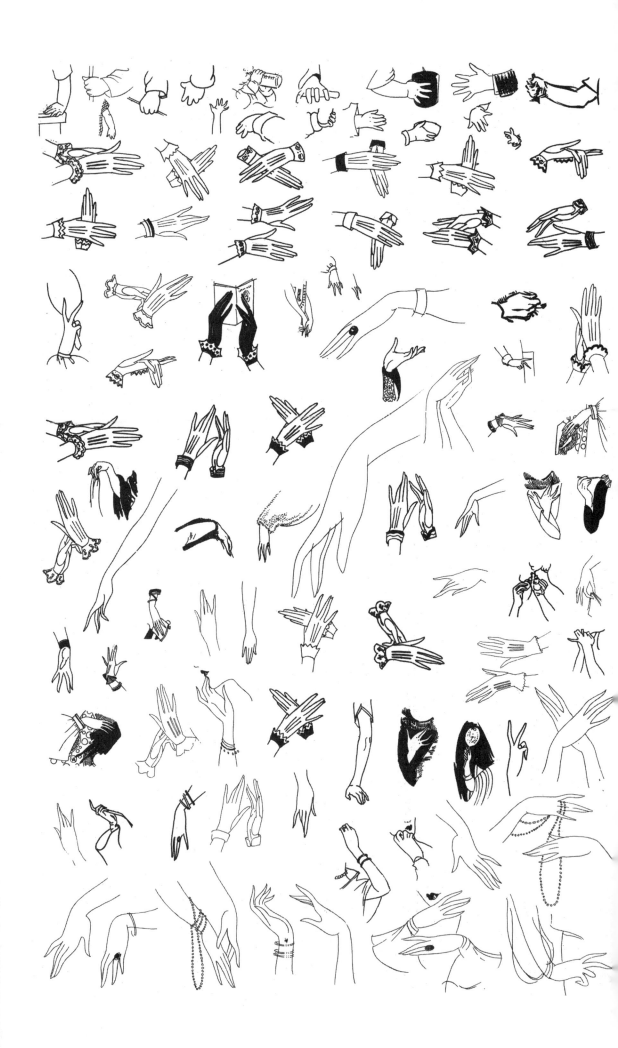

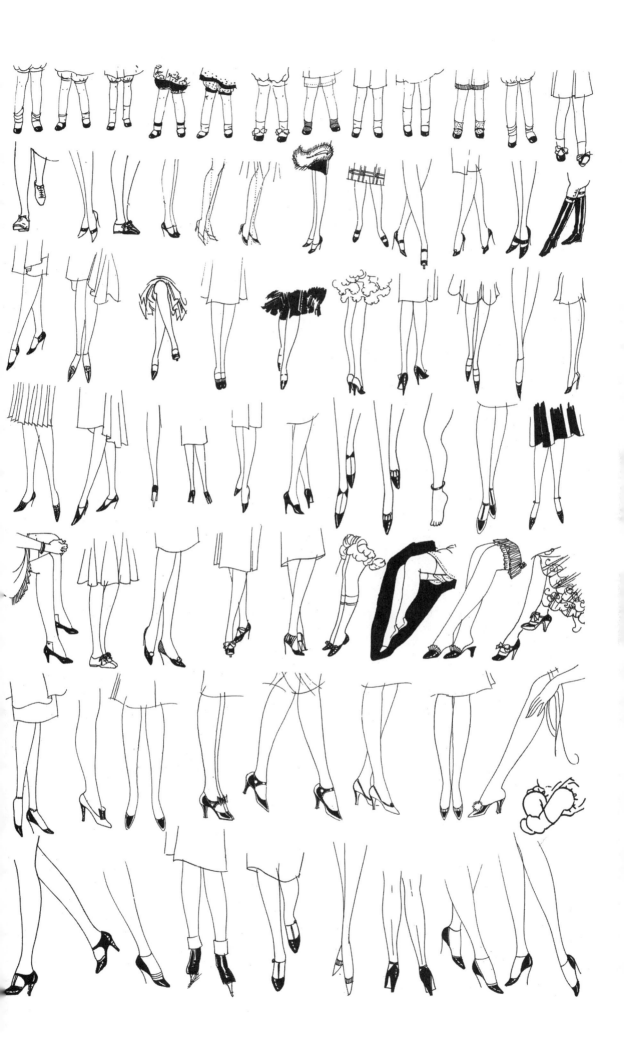

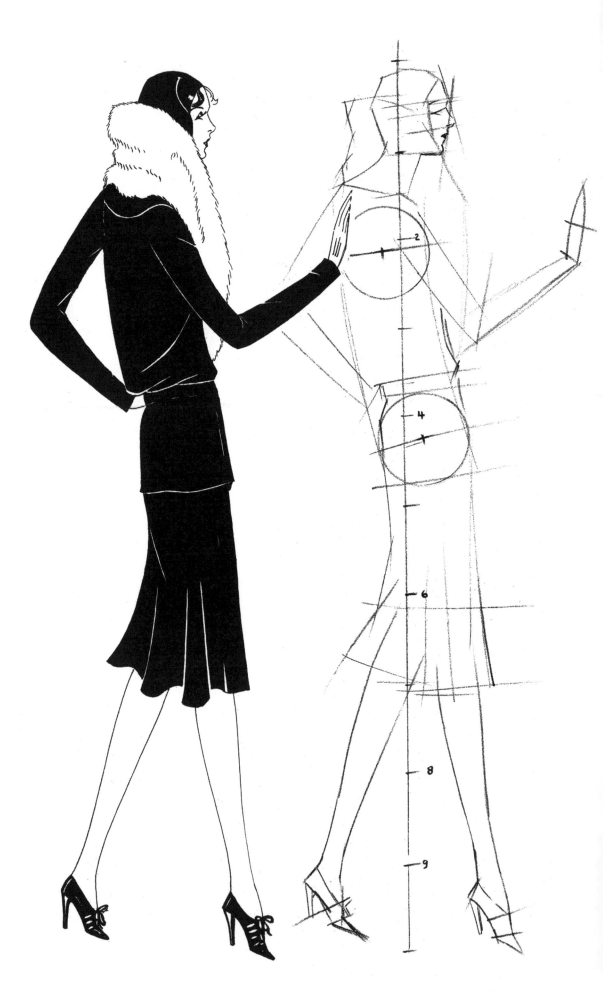

See Direction Sheet

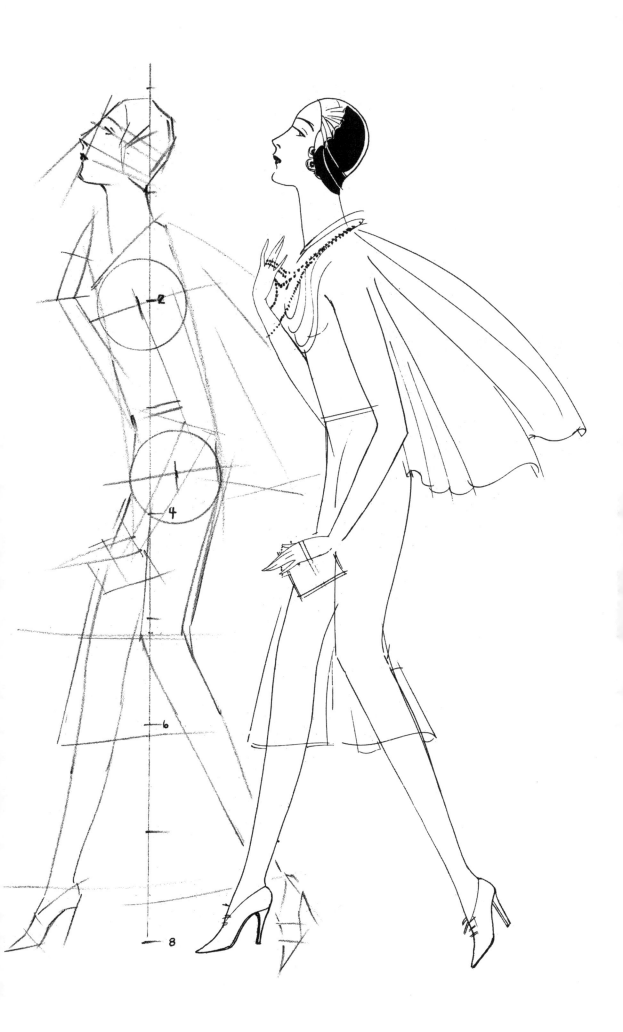

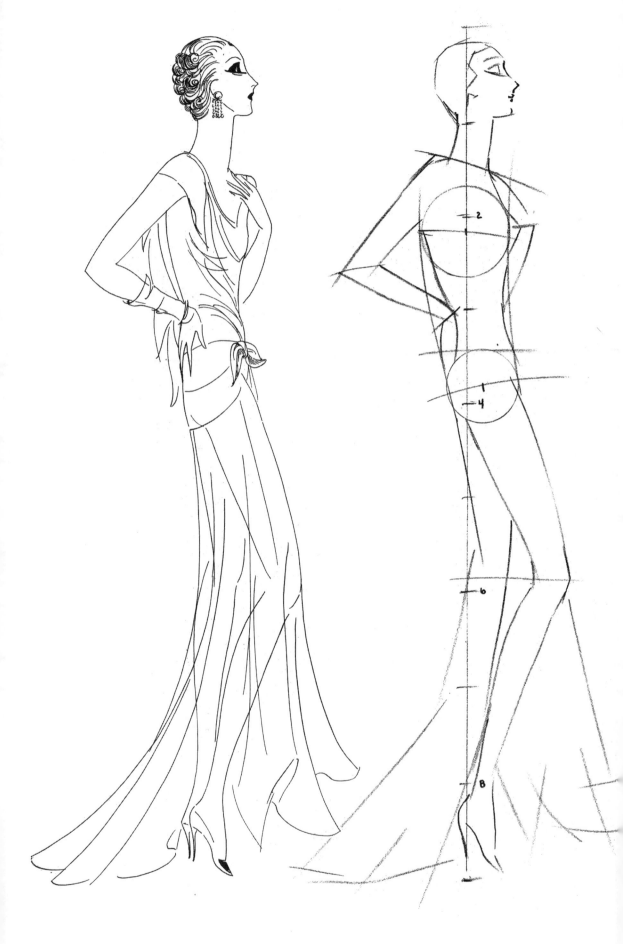

See Direction Sheet

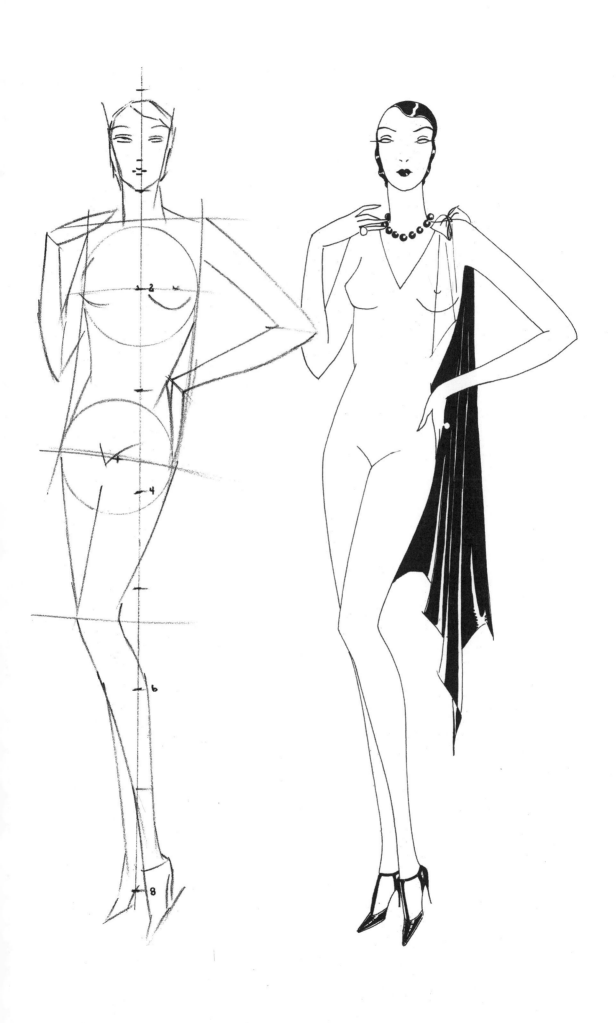

How to Draw the Figure: Female Fashion
Part II

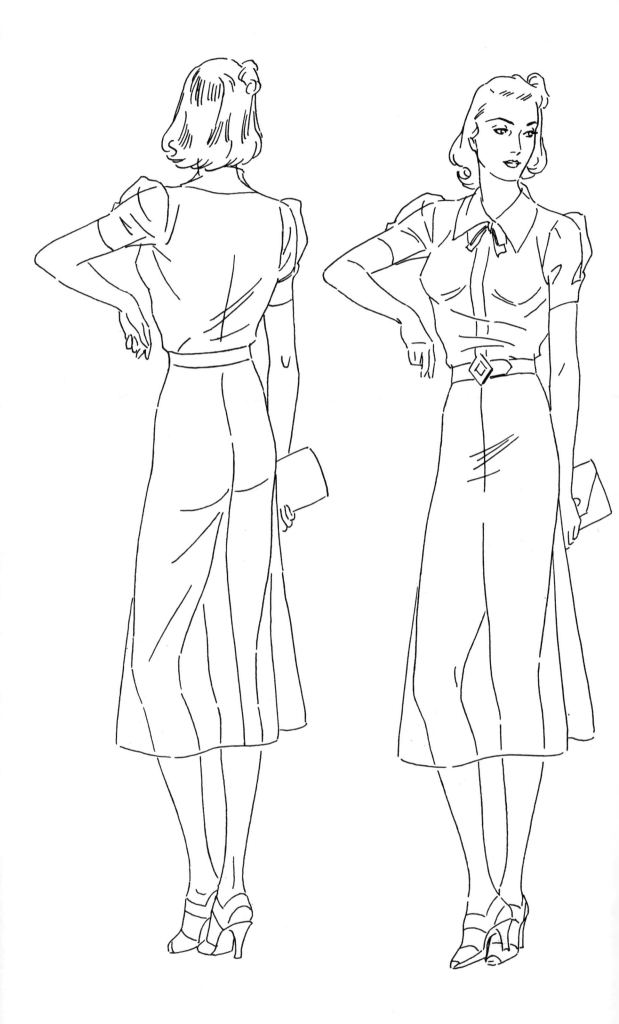

Directions

Draw a vertical line, divide into eight heads, mark off 2, 4, 6, 8. Place eyes at one-half head, (See "How to draw the Head")

When you are inking in long lines, as arms, legs or dress lines, turn paper sideways, so you will not pull the long strokes toward you. —

Remove thumb tacks after squaring up your drawing. When inking in it is best not to tack drawing to board. Have paper so you can turn in any position best suited for freedom of lines.

Draw leaf shape for hands, divide in half, draw fingers last.

A

C

B

D

It is a waste of time to make squatty or short figures.

If you devote much time drawing short figures tall ones will not look right.

Student or artist must remember when drawing from life that the human figure is elongated when used for fashions, or illustrations, especially the female figure.

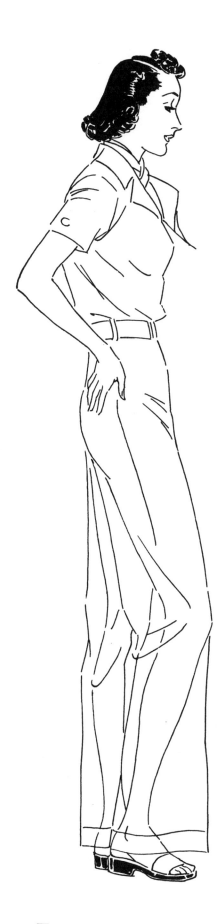
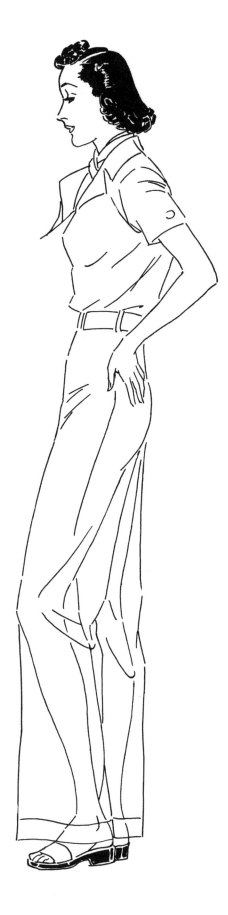

JOIN a life class and make dozens of two to five minute sketches of hands, feet, ears and most of all for a good understanding of the body. You must make the clothing look like it covers a real body, so you must know anatomy.

I wish to emphasize how necessary it is to first think what you are doing—get out of the habit of scratchy lines. A few well-chosen pencil strokes will be less confusing and show through your finished work, giving crispness and freedom, whether oil, water color, pen and ink or wash

If this is followed you will develop a style all your own, will be able to visualize measurements and eliminate much of the guesswork.

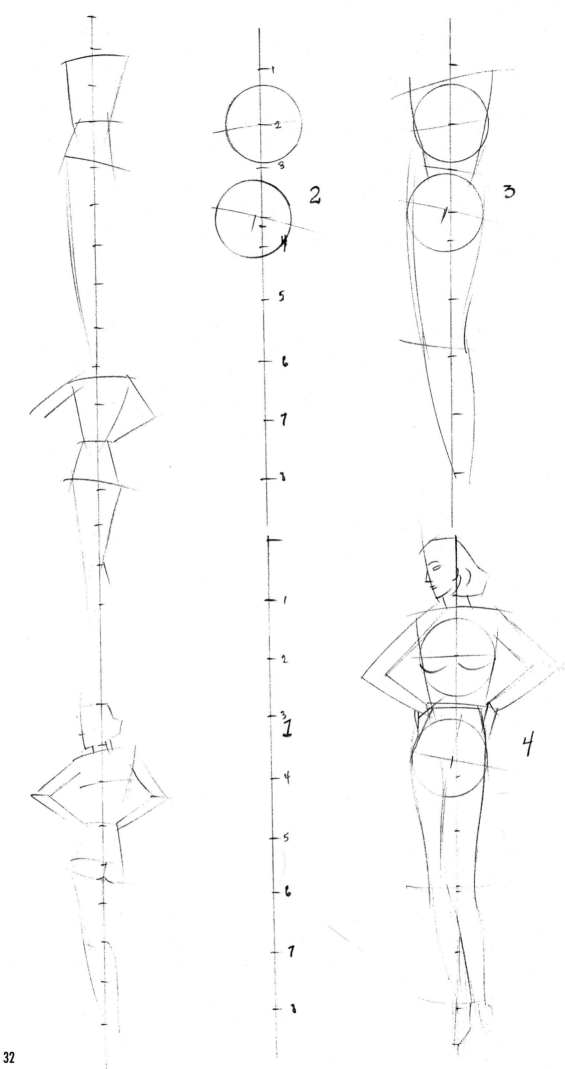

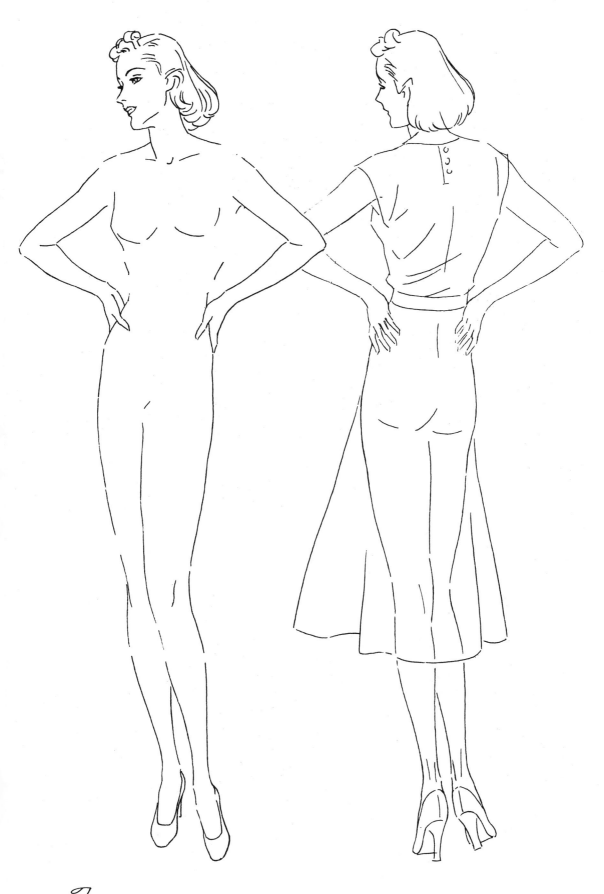

These drawings are not so stylized that
you hang a sign on your drawing
"Taken from so and so's drawing."
You can exaggerate or simplify the
figure and it becomes your own.

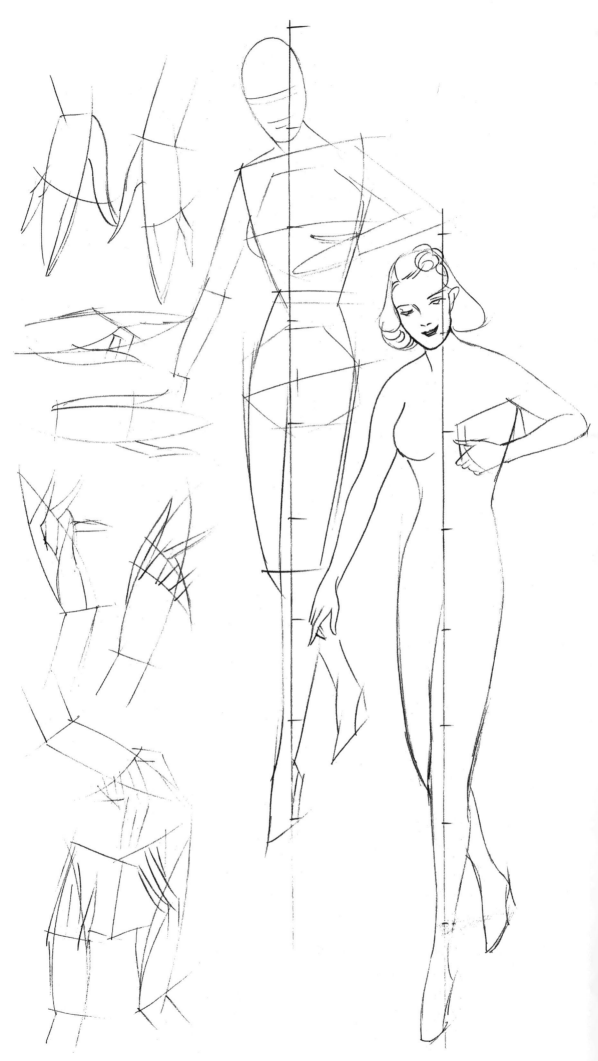

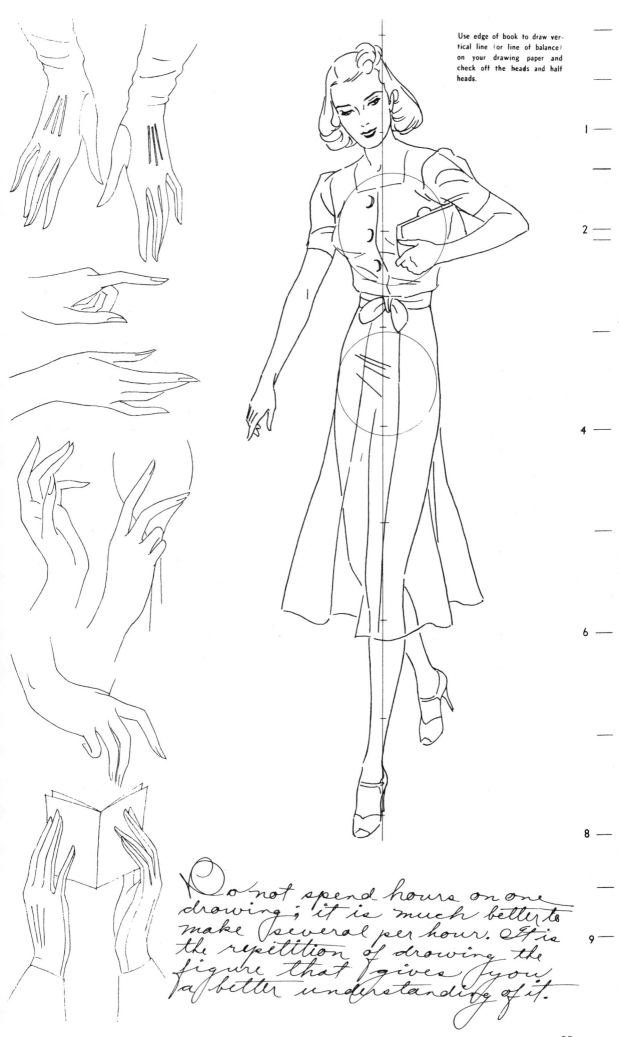

Use edge of book to draw vertical line (or line of balance) on your drawing paper and check off the heads and half heads.

Do not spend hours on one drawing; it is much better to make several per hour. It is the repetition of drawing the figure that gives you a better understanding of it.

35

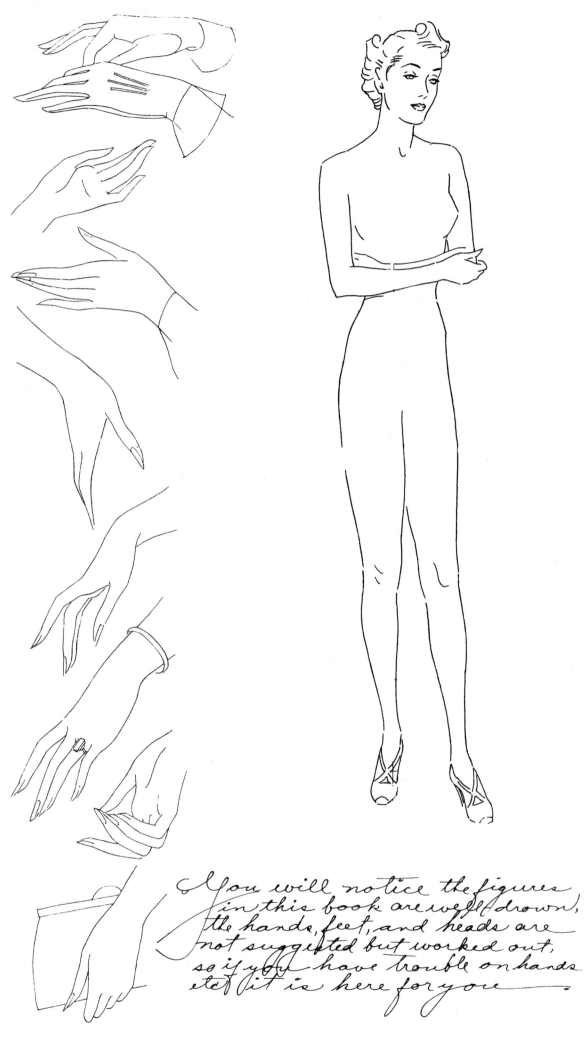

You will notice the figures
in this book are well drawn,
the hands, feet, and heads are
not suggested but worked out,
so if you have trouble on hands
etc it is here for you

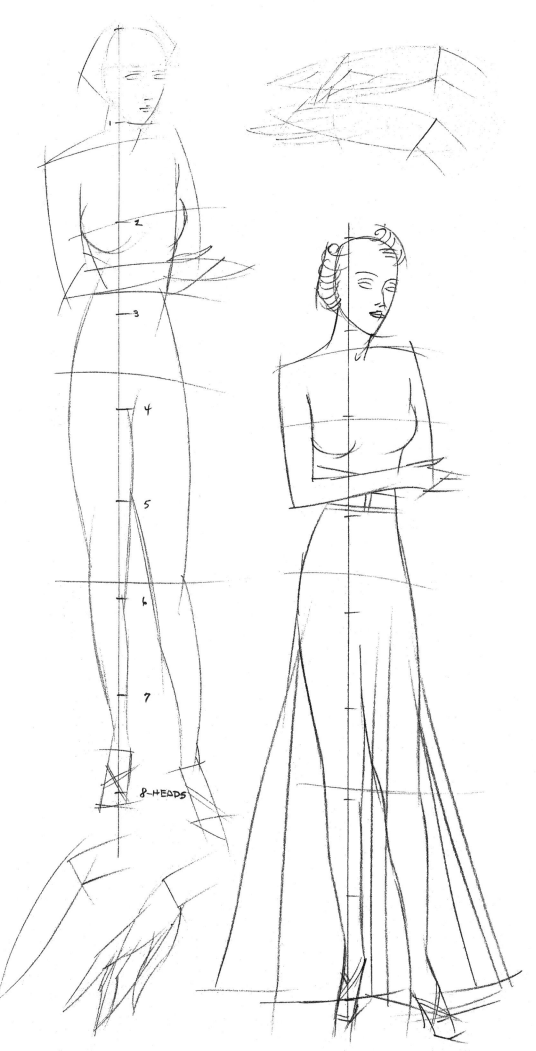

1

2

3

4

5

6

7

8-HEADS

Do not expect too much of yourself at first, but once the art bug gets you, you are destined to a life of pleasure wherever you go; people, country cities take on a different meaning and all have a greater value to you.

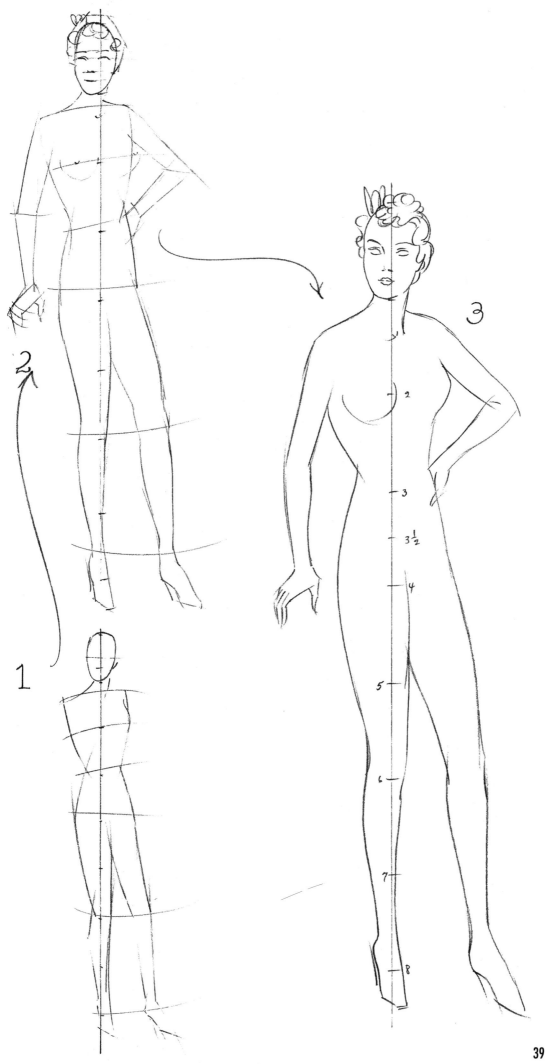

1

2

3

2

3

3½

4

5

6

7

8

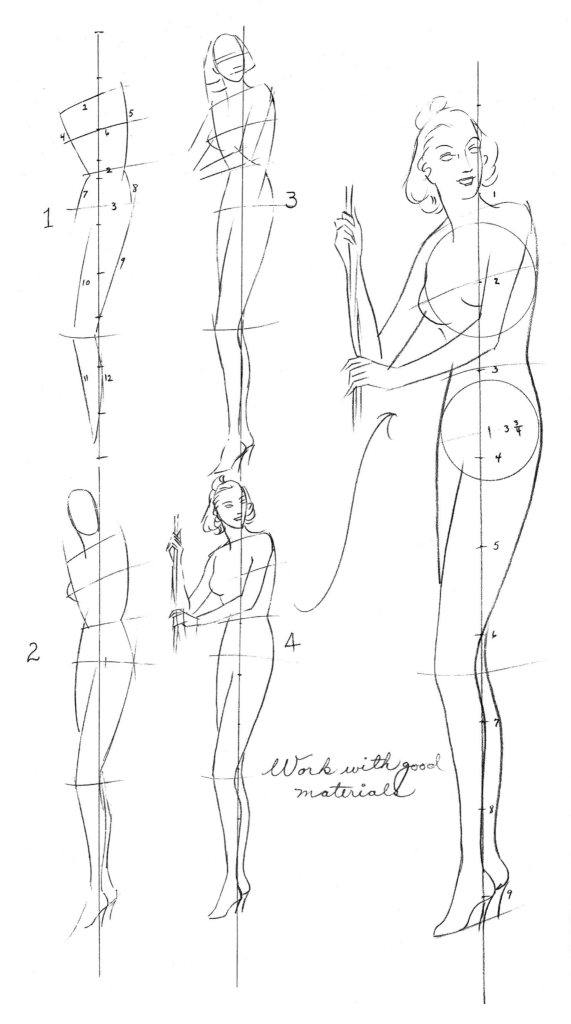

Work with good
materials

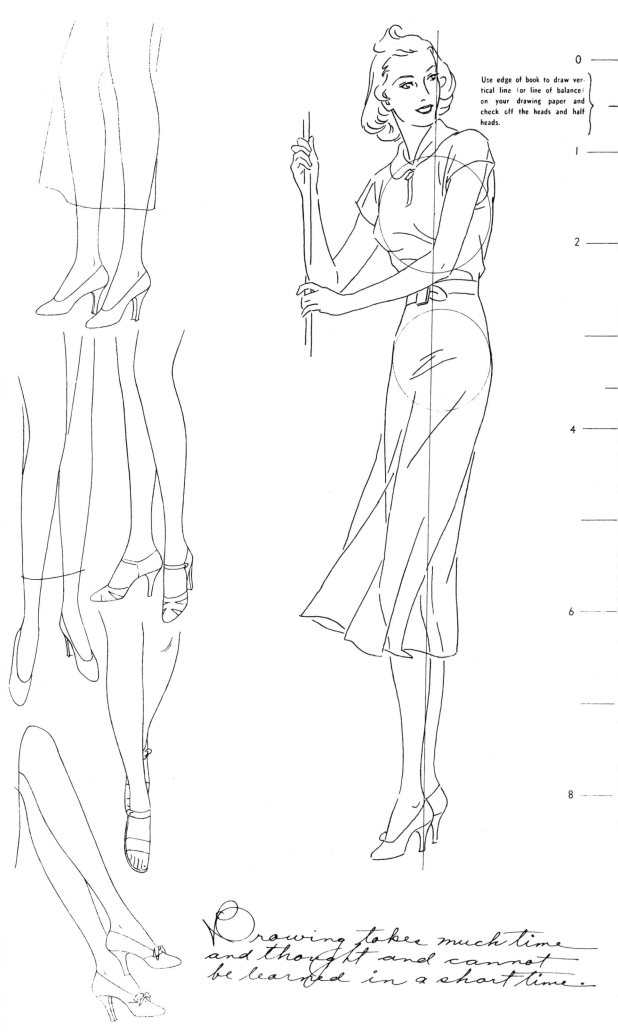

Use edge of book to draw vertical line (or line of balance) on your drawing paper and check off the heads and half heads.

0

1

2

4

6

8

Drawing takes much time and thought and cannot be learned in a short time.

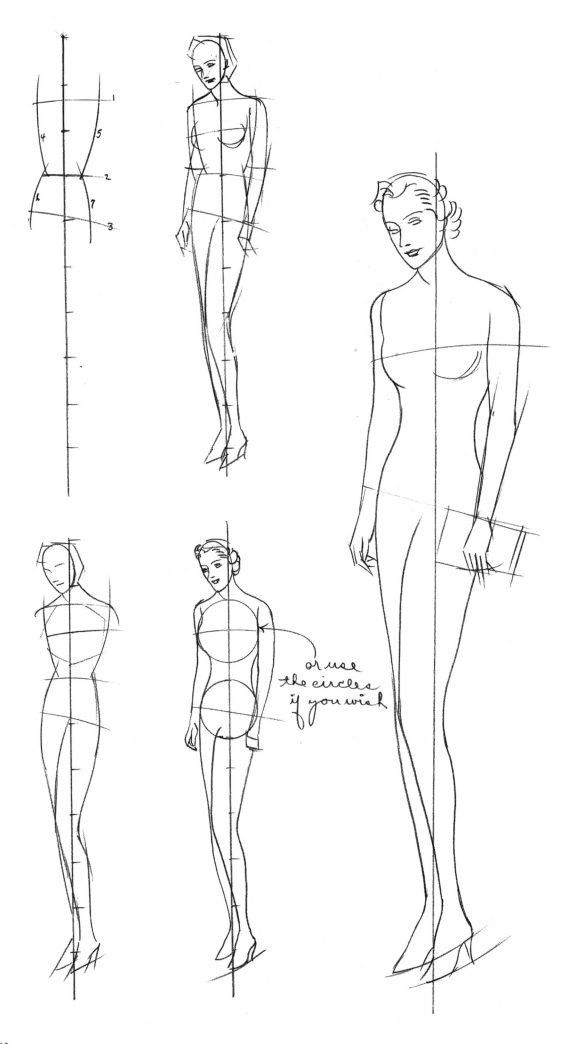

or use
the circles
if you wish

So many spend hours, months,
yes years, learning and drawing
the human figure, with but
little thought to the application
— and this is so essential if you
wish to use it in a commercial
way, illustrations, fashions etc.

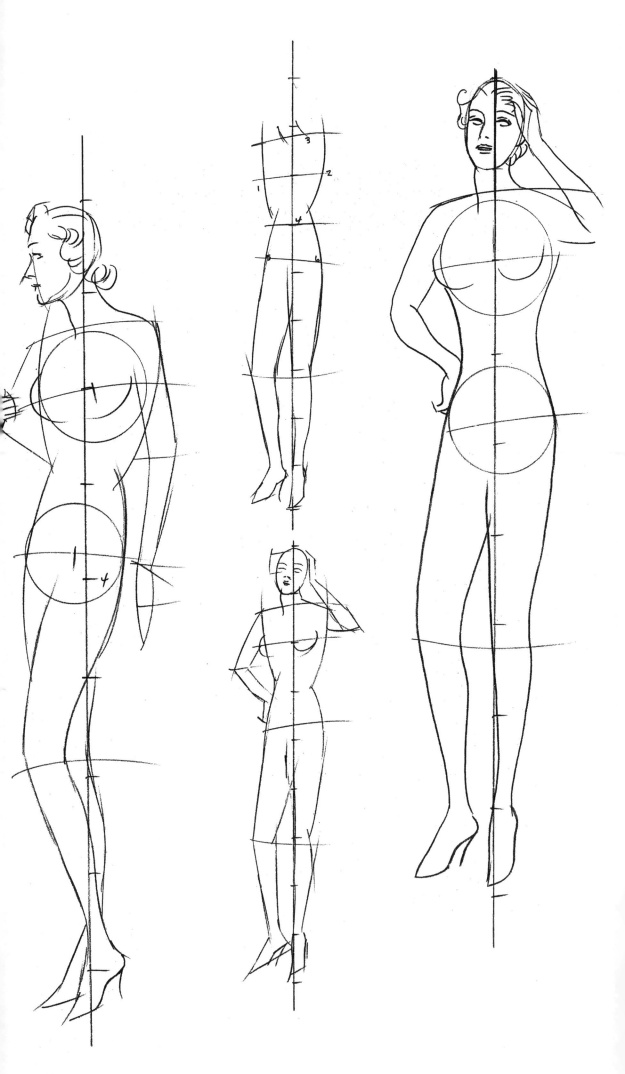

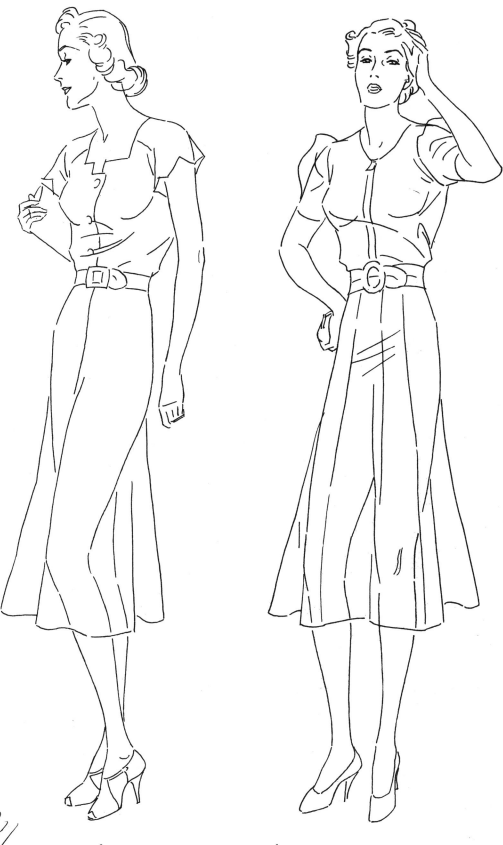

Many artists work their pencil drawings out on tracing paper, tracing the figure or design on Bristol board or illustration board, then ink in or use water colors. In this way you can adjust your design to right or left, up or down. It makes a much cleaner drawing and does not disturb the surface of your paper.

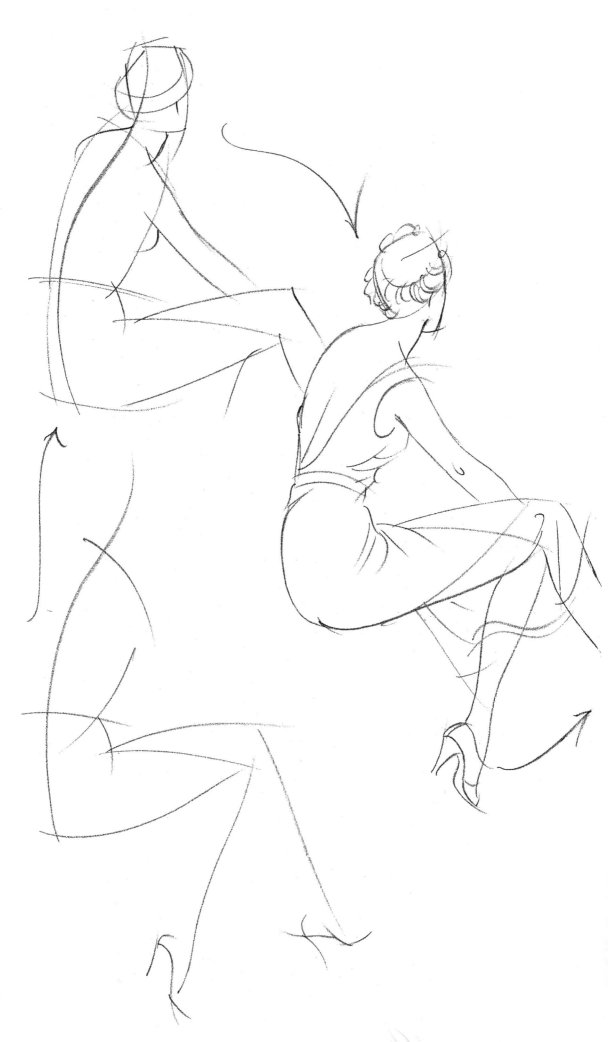

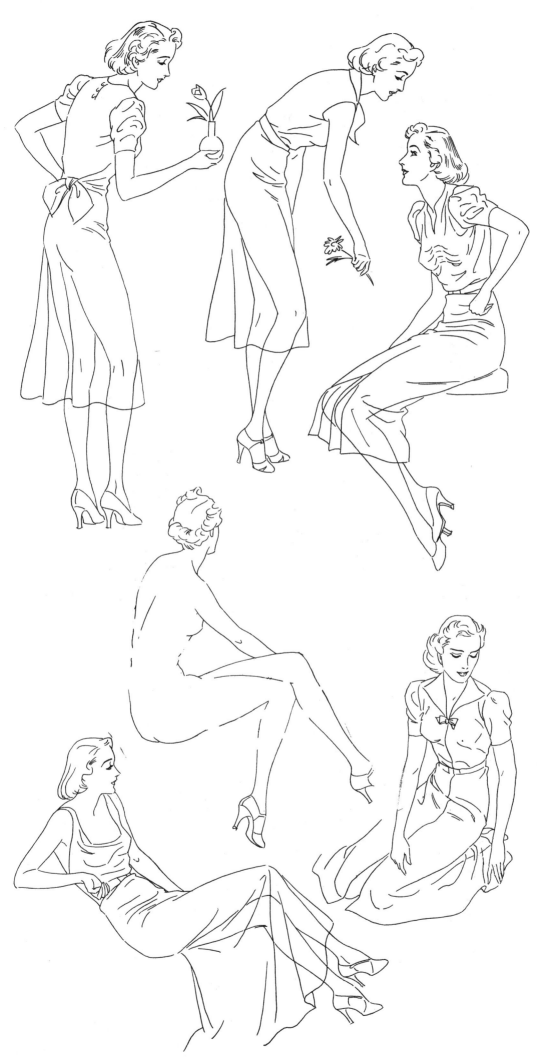

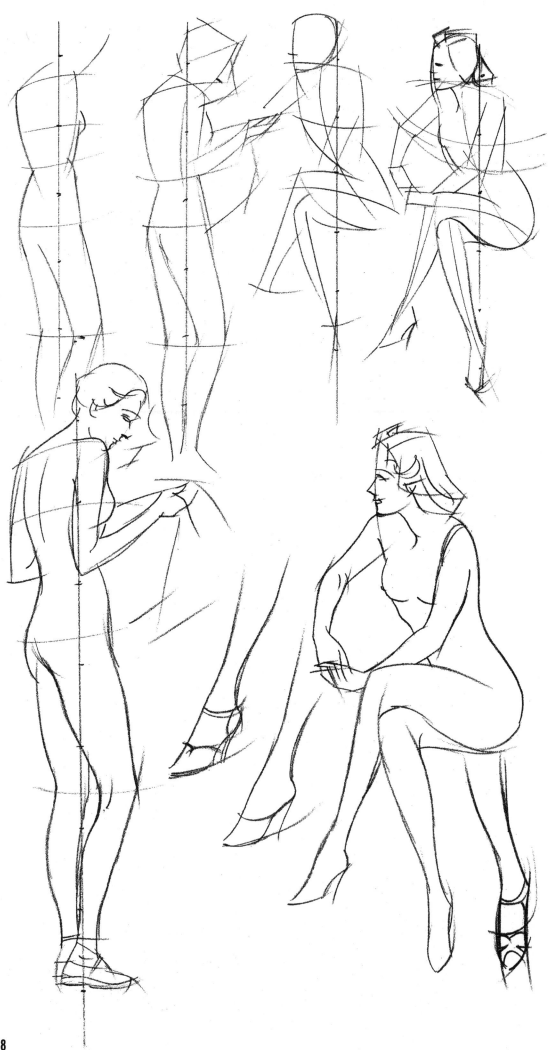

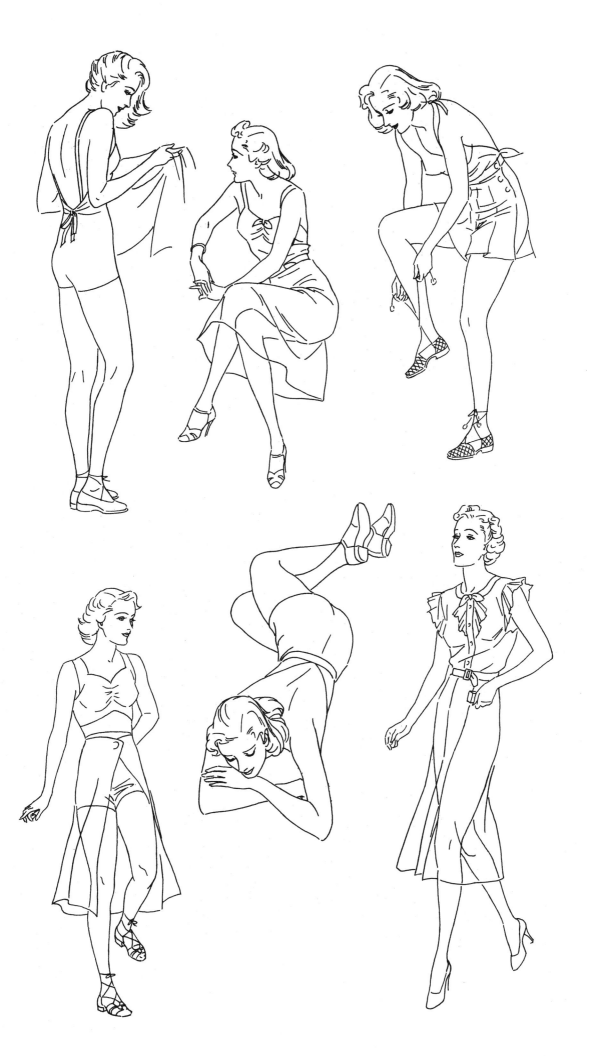

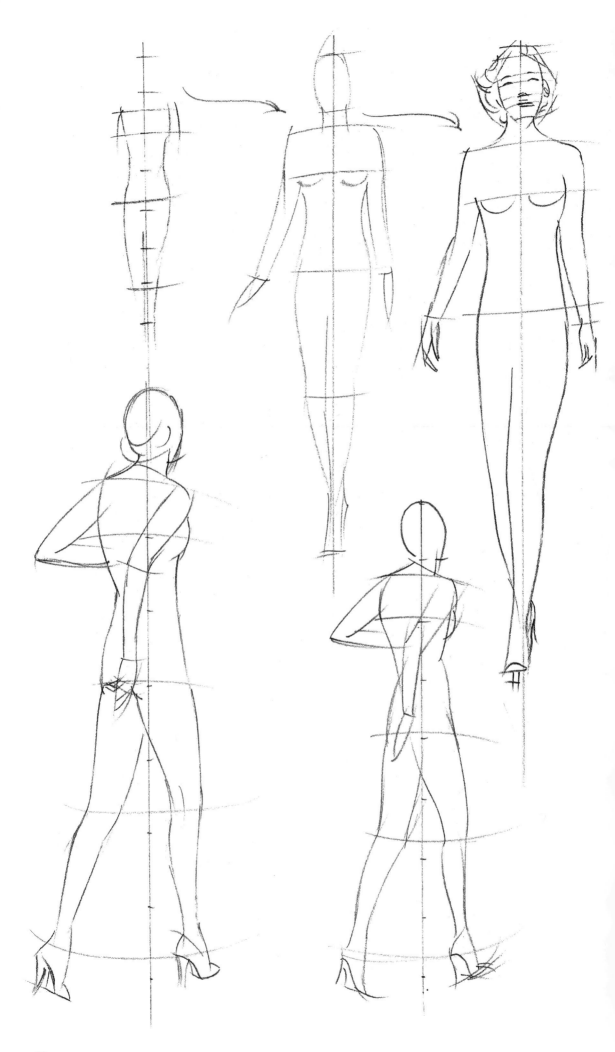

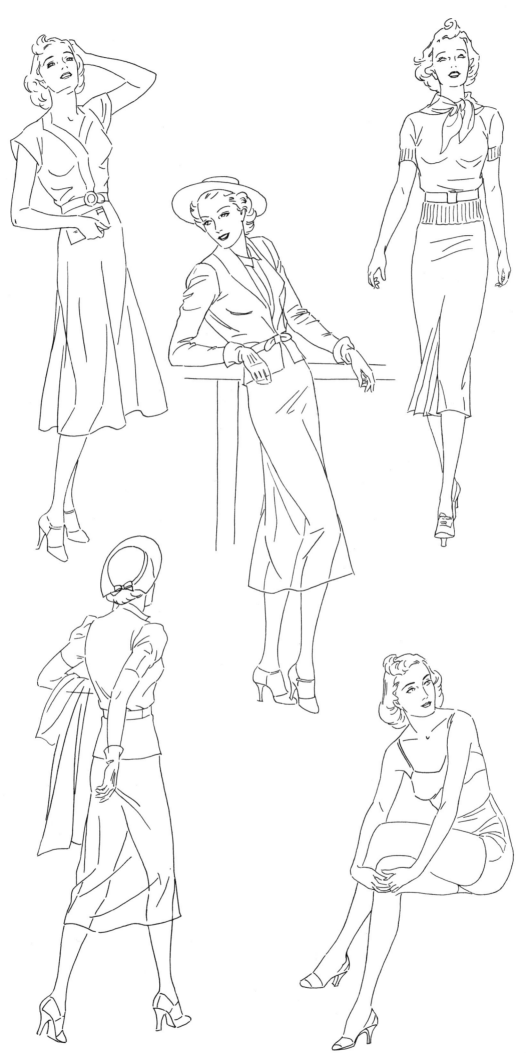

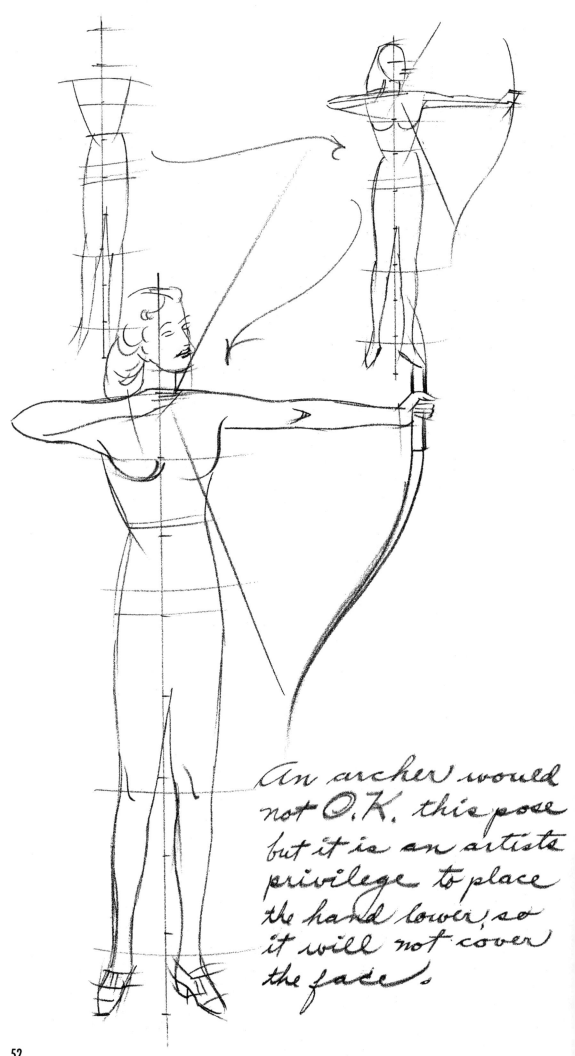

An archer would
not O.K. this pose
but it is an artists
privilege to place
the hand lower, so
it will not cover
the face.

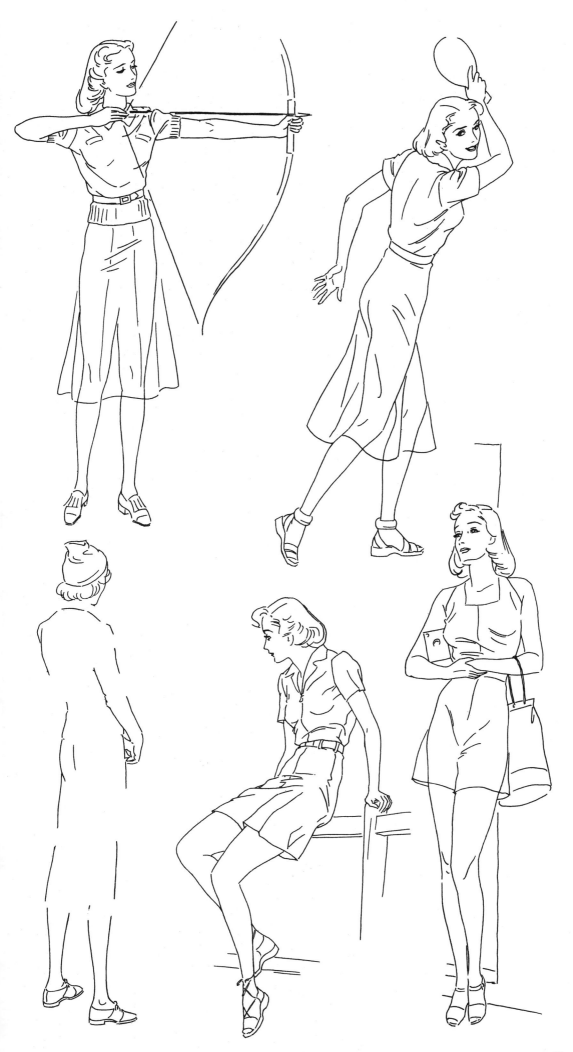

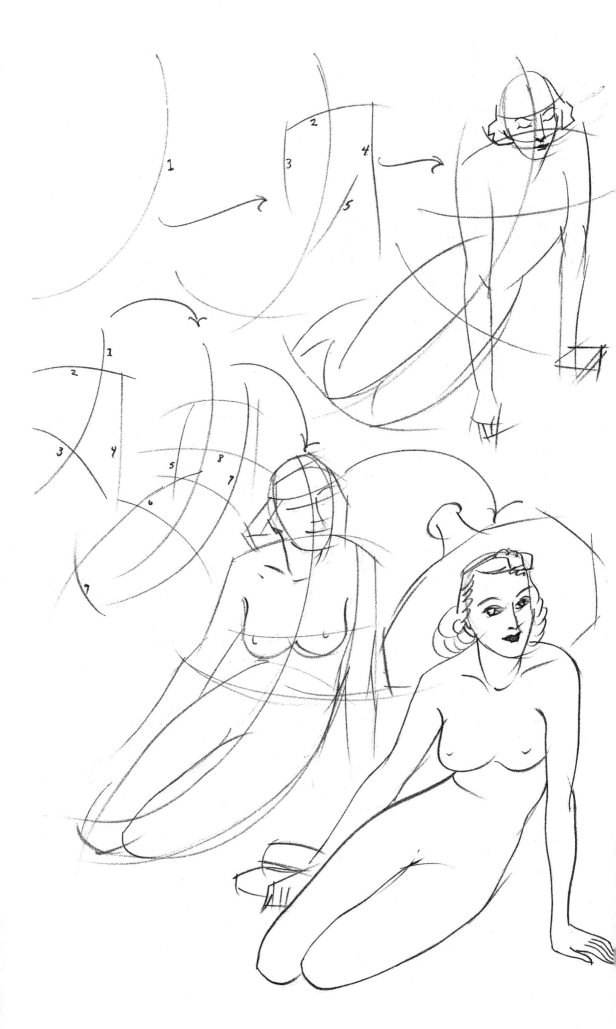

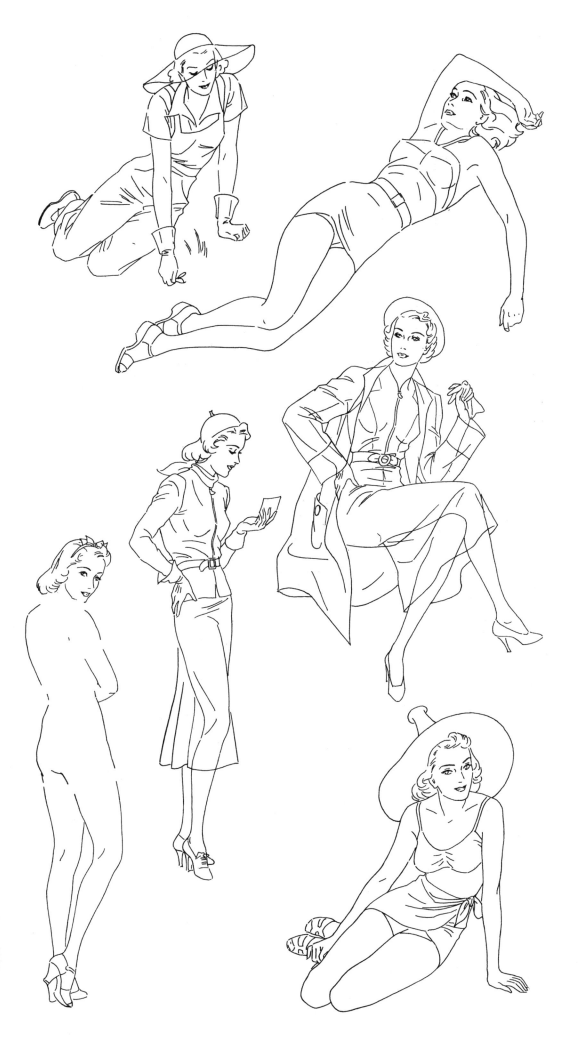

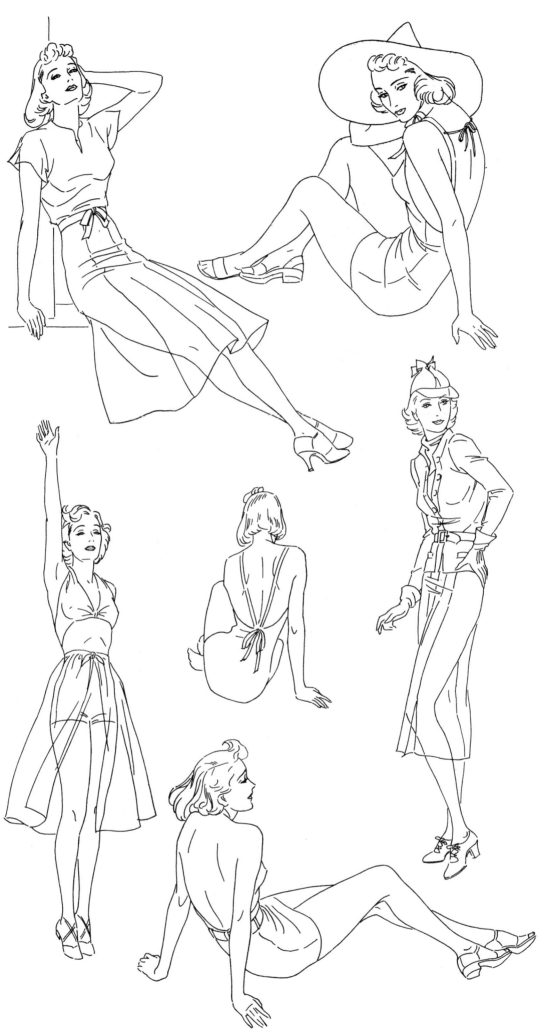

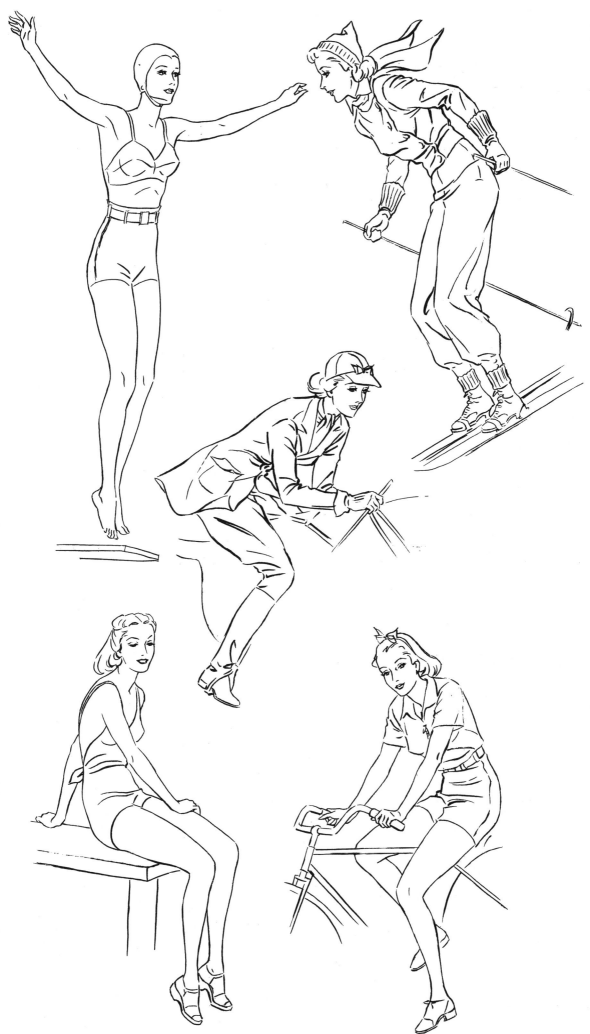

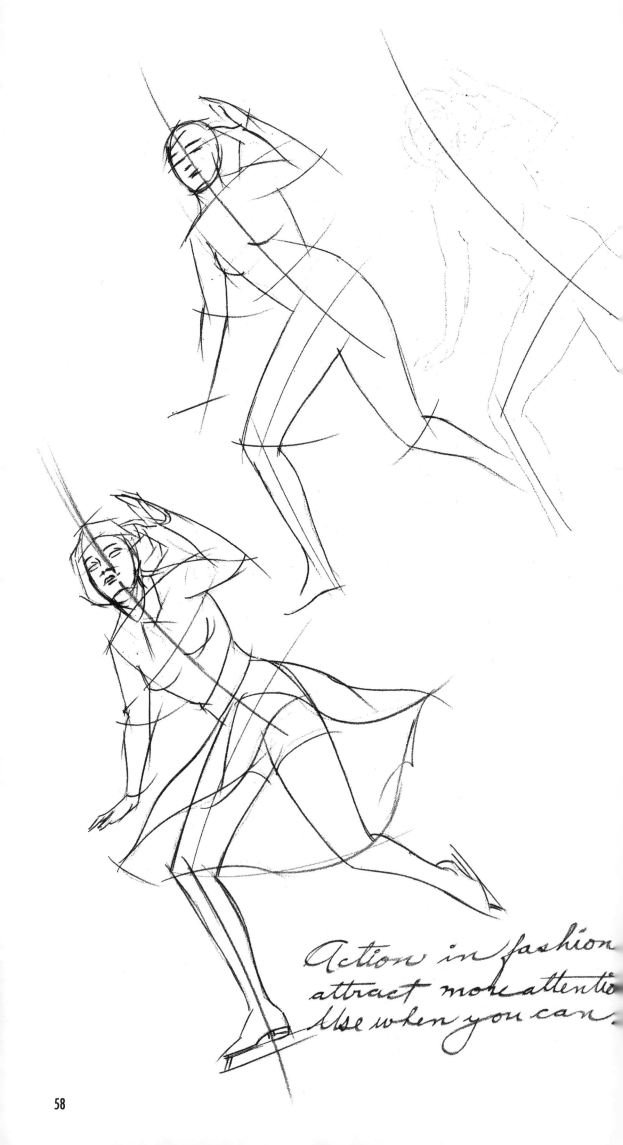

Action in fashion attract more attention. Use when you can.

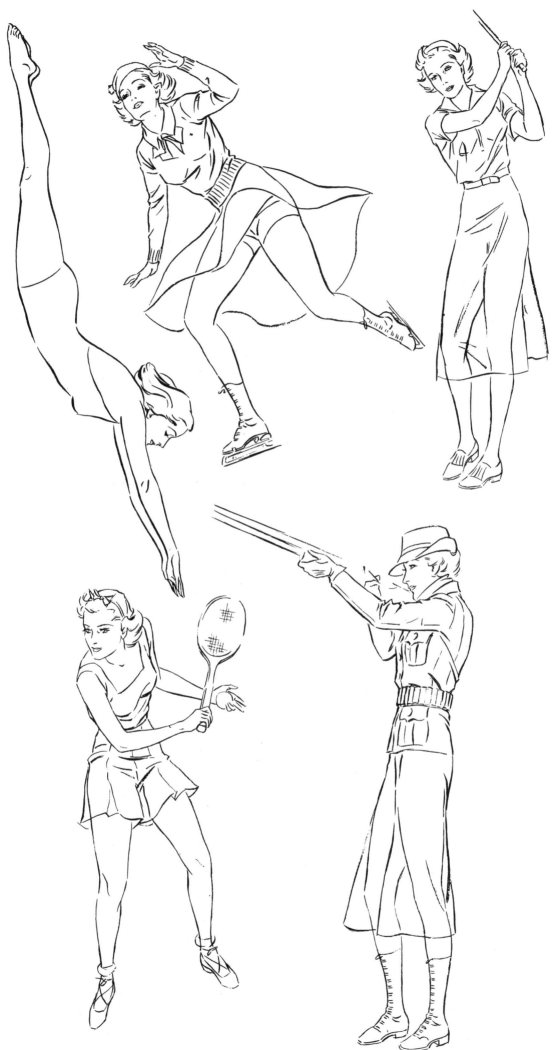

13

12
11

2

14

15

16

18

3

17

1

2

5

6

3

1

7

4

8

9

10

Erase
guide lines
and clean
up drawing

4

Poses that are
unusual are
good to use

60

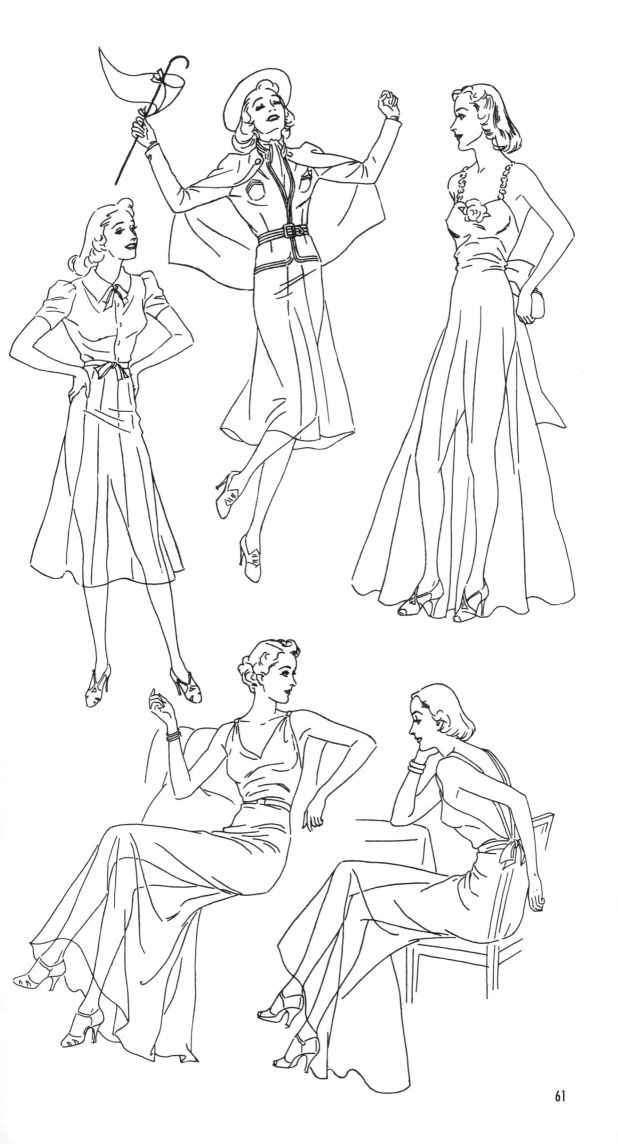

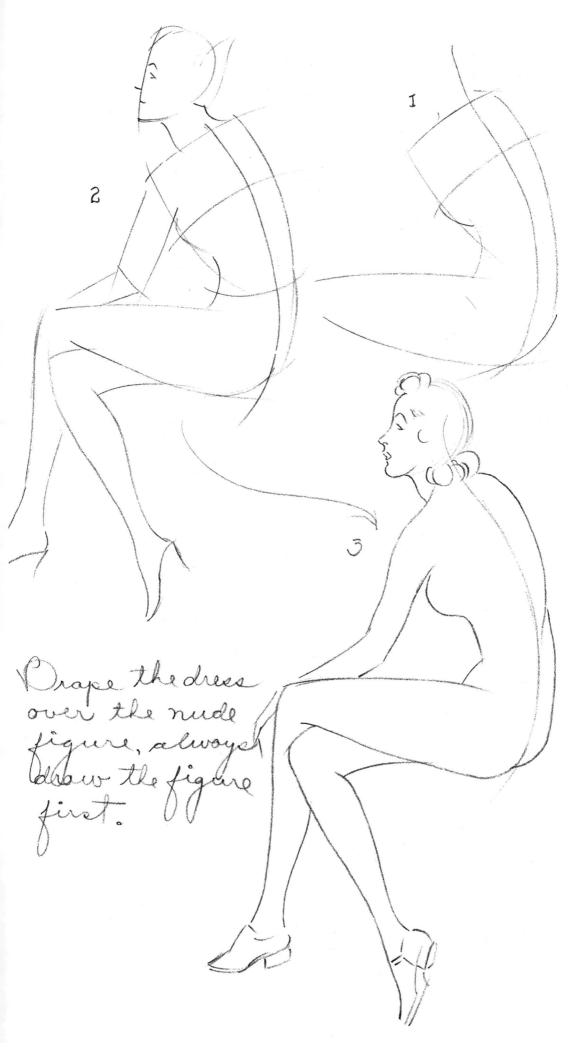

Drape the dress
over the nude
figure, always
draw the figure
first.

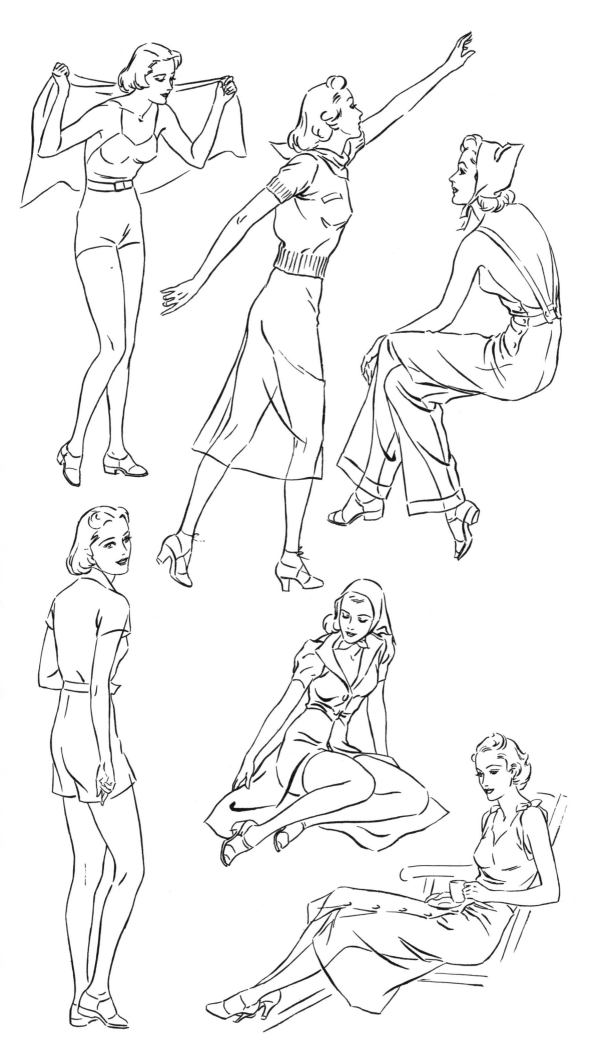

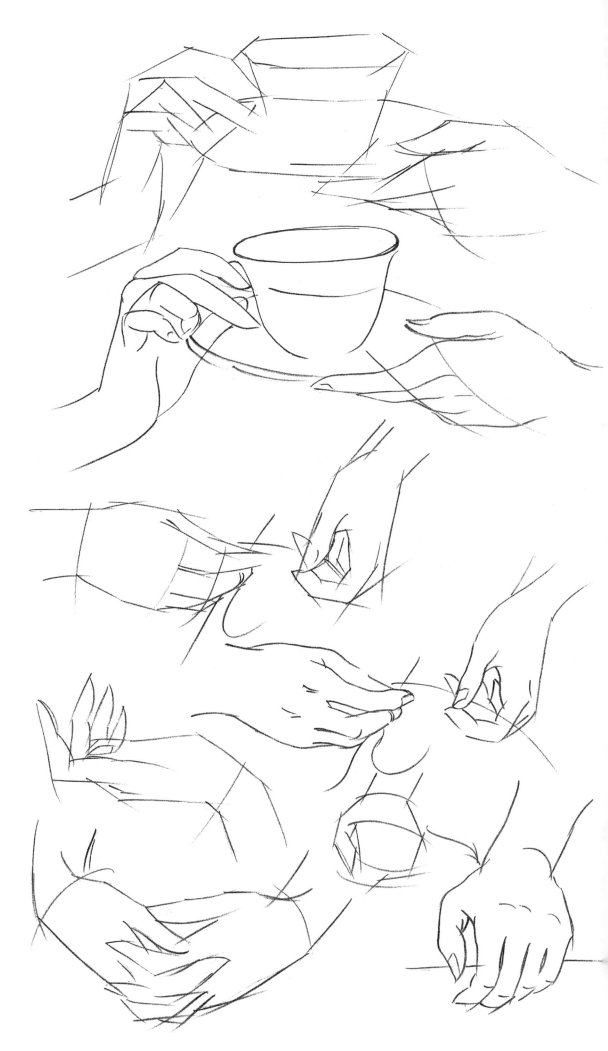

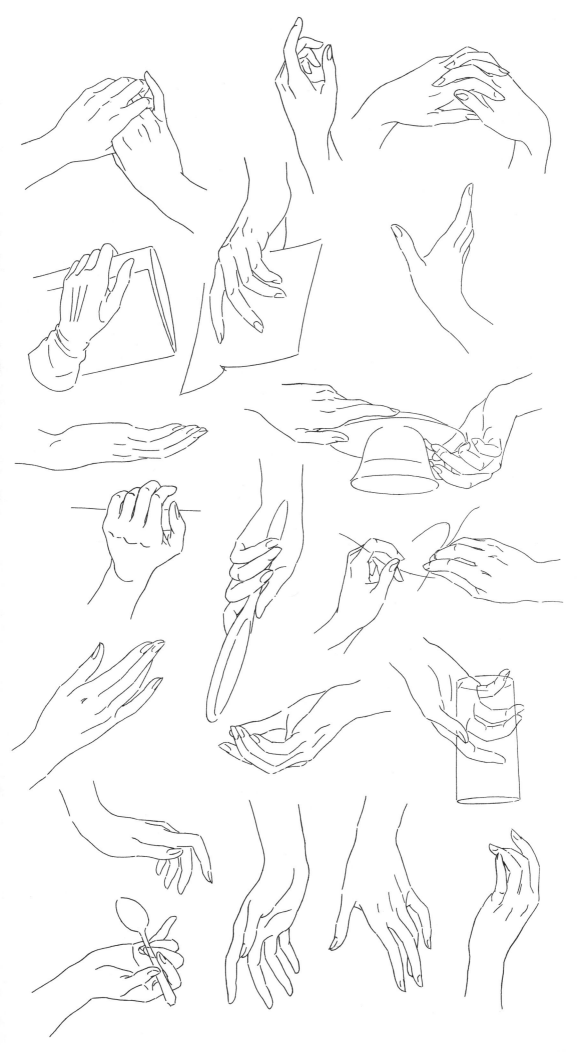

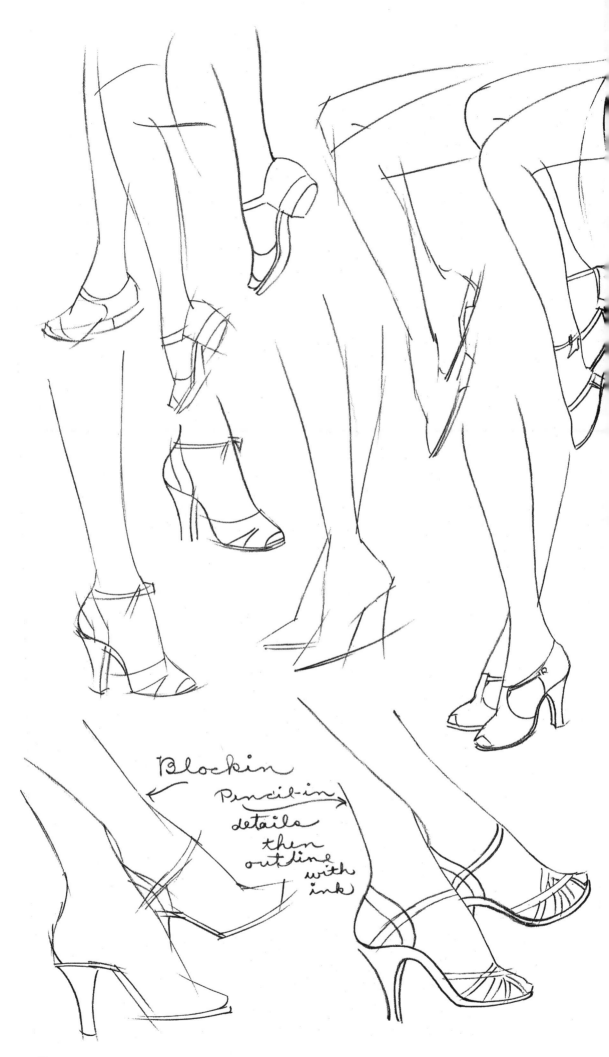

Blockin

Pencil-in
details
then
outline
with
ink

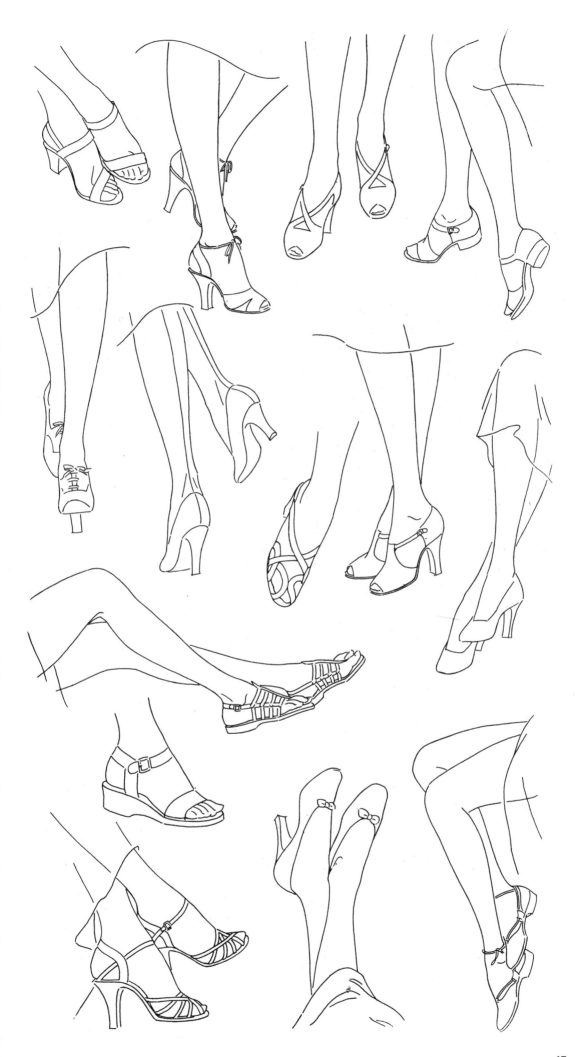

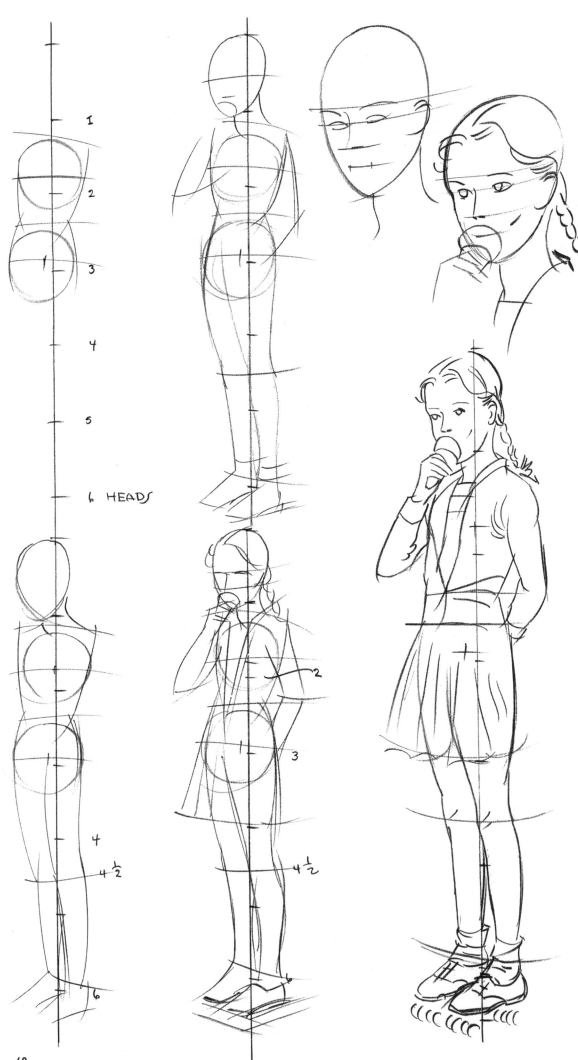

1

2

3

4

5

6 HEADS

4

4½

6

2

3

4½

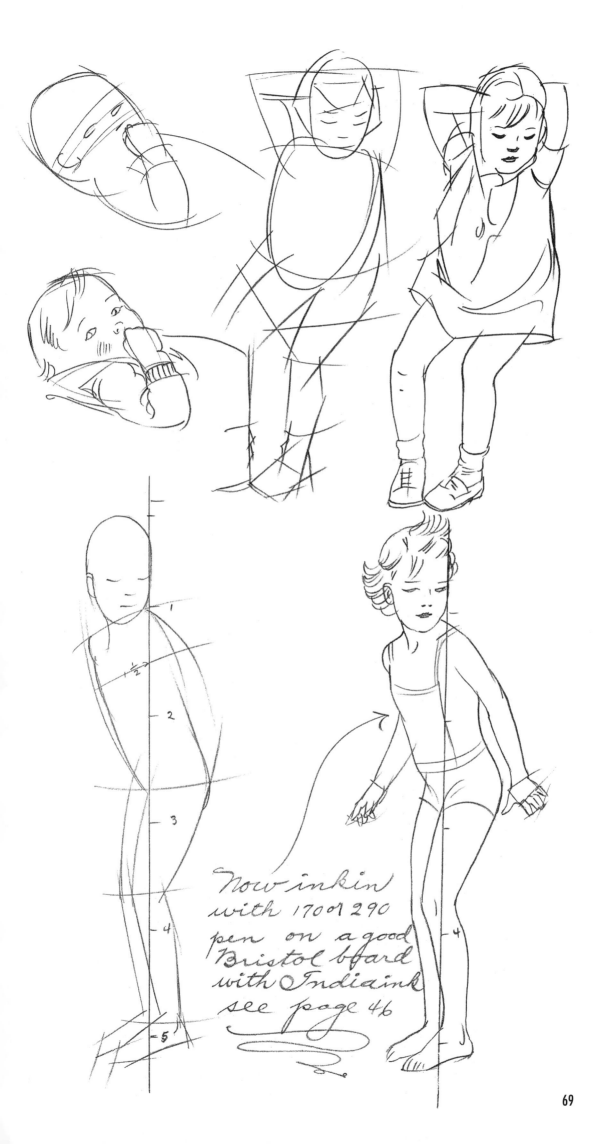

Now inkin
with 170 or 290
pen on a good
Bristol b'ard
with India ink
see page 46

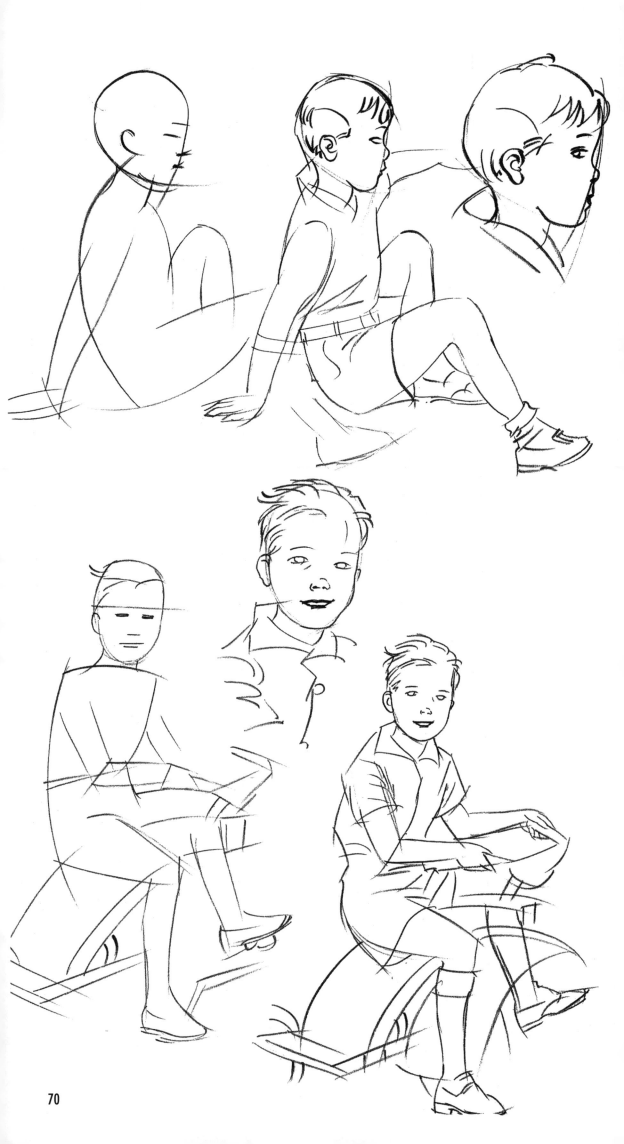

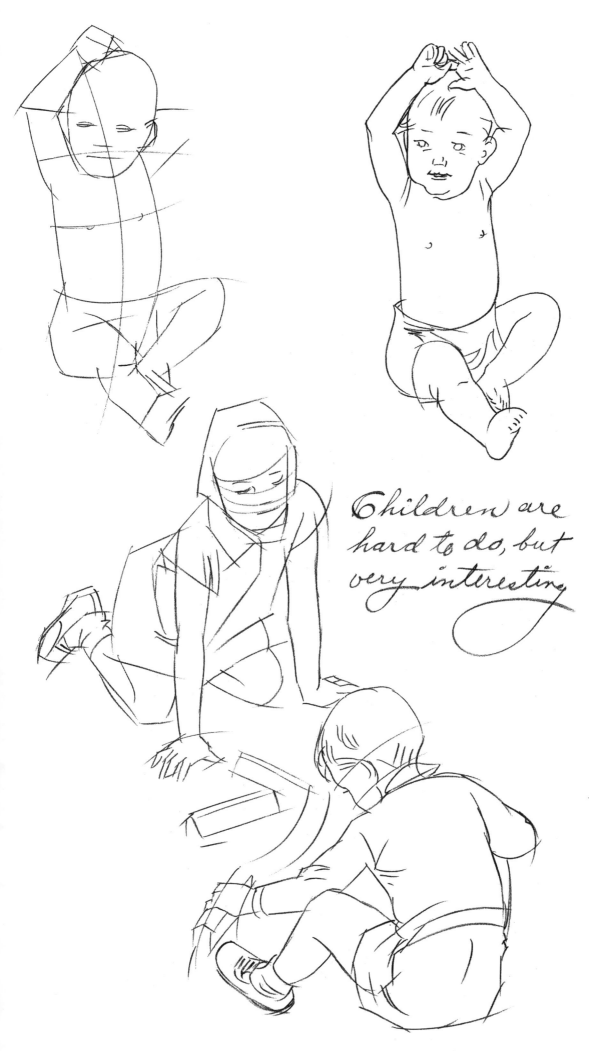

Children are
hard to do, but
very interesting.

Be neat in your work
regardless how many
times you have to do
it over———.

It doesn't take a friend
or pull to sell good work.

72

Do not worry about a style or technique they will come with study and understanding in fact you can not help having one anymore than you can eliminate your personality; just be sure it is pleasing

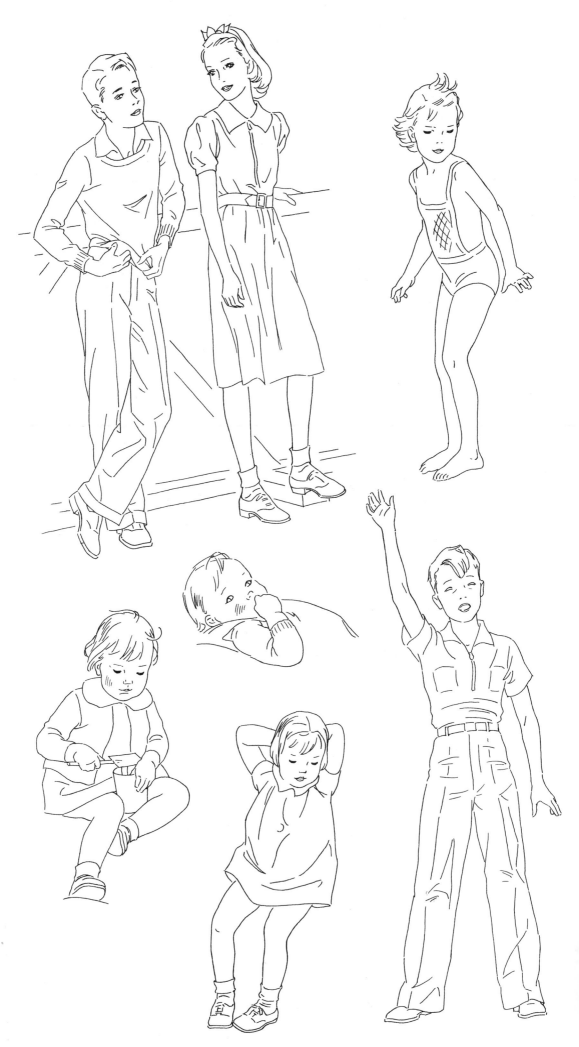

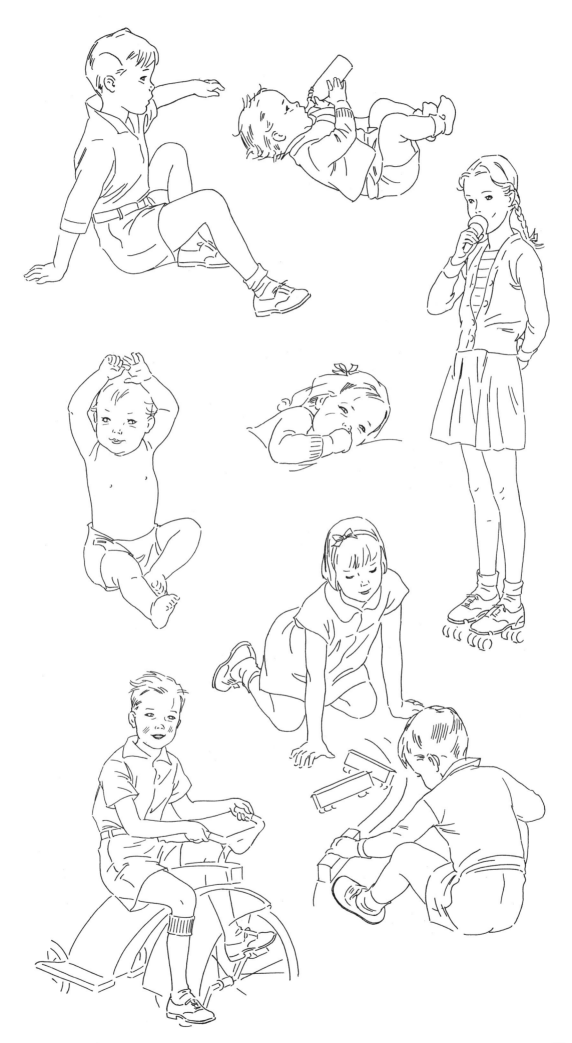

How to Draw the Figure: Male Fashion
Part I

Directions

1

It is essential that you know the proportion of the head, and you should know how to draw it well. See my book "How to Draw the Head," it will help you. First, draw vertical curved line, then draw eyebrow line which will give you placement of ear, then nose, mouth and chin.

2

Block in nose, eyes, mouth. Shape up head, work over blocking in of eyes, mouth, etc.

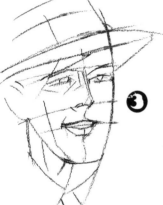

3

Clean up drawing. See No. 4. Now you are ready to start on the wash drawing.

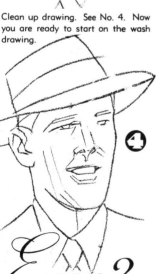

4

Easy?

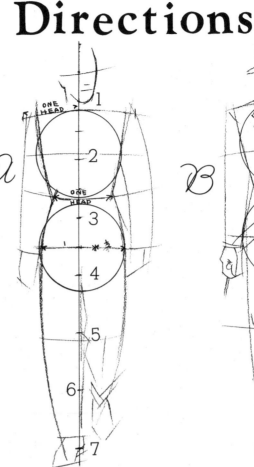

A

Draw vertical line, divide into 7 parts; this represents the height of the figure in heads. The body circles are 1½ heads.

C

Draw in pockets, folds and shape up face, hands, shoes, etc.

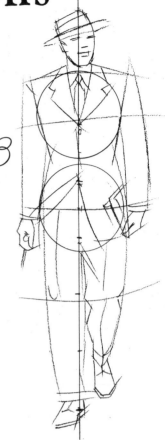

B

After checking proportions, block in the coat, hat, hands and shoes.

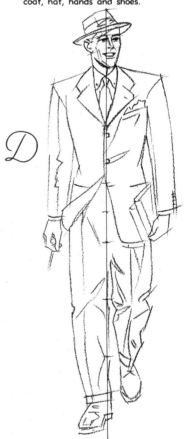

D

After rounding out your blocking-in and completing your drawing, you are now ready to complete your wash drawing.

No, I wouldn't say that, but with diligent study and practice you will find this procedure much easier than the hit-and-miss method most artists and students use in drawing the figure.

Refrain from making scratchy, meaningless lines; try drawing this way for awhile and you will see a great improvement in your finished drawings. Pleasant going. As ever,

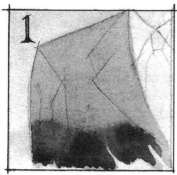

If you have too much color when ending your wash, as in No. 1, squeeze color out of brush and pick up surplus color while wet. At first you may take up too much, but practice will correct this.

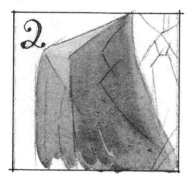

When first wash is quite dry, apply second wash. Use good No. 6 watercolor brush. Rest your hand on a sheet of clean paper while working; this will keep the oil from your hand off the paper avoiding spots.

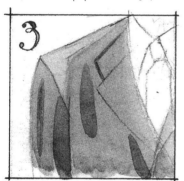

Try out your color on a piece of scrap illustration board or paper before applying on your drawing. This will save you lots of headaches.

Now, after the last application you are ready for the fabric. After completing fabrics use Chinese white to clean up rough spots and where you have run over edges with wash. also for highlights.

Wet surface to be covered, with clean, clear water. Let it almost dry before applying first color wash. The clear water will help prevent hard edges and give you smooth tones.

All drawings are reproduced actual size so that you may study them. The drawings in newspapers and magazines are made one-third to twice the size you see them in print. Some artists work originals even larger.

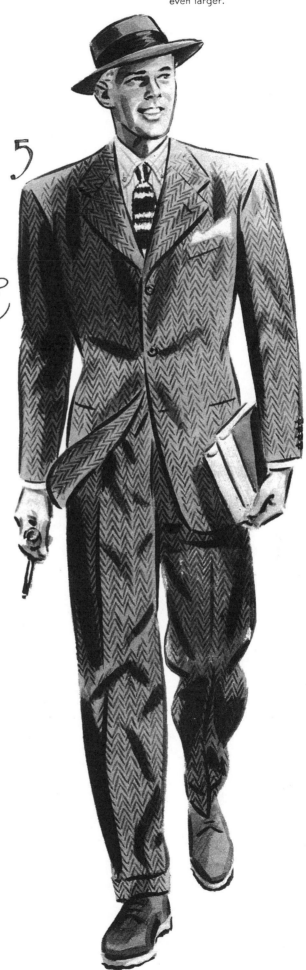

ᗰATERIALS..Your local art store can supply you

Drawing table or drawing board that can be held on lap, leaning on top of table at a slant. Best size is 23"x31" for most work.
Brushes (round red sable): Two No. 3, one No. 6. A No. 12 for large washes but not necessary to start. Do not buy poor brushes. Good ones last long and are nice to work with.
Color slab; or saucer will do.
India ink (waterproof), any good brand.
Half or whole pan of lampblack or small tube. White opaque in small jar.
Crayon pencil, negro leads, for shading over wash.
H. B. pencil for drawing or No. 71 Scripto with H. B. leads. A good size jar of any kind is all right for water, change when it becomes clouded.
Paper: You can buy several grades of illustration board to practice on.
Take good care of your brushes —always wash with clean water, shape up to a point between your thumb and two fingers. Have a No. 3 brush and use only with India ink, wash with soap and water when it becomes caked.

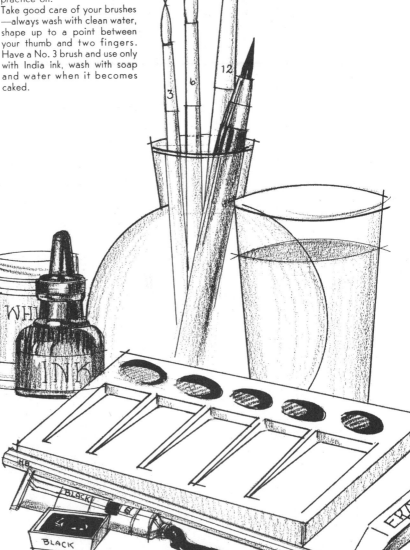

You can use either tube or pan watercolor or both if you wish.

The washes should be mixed in the trays. It is well to have enough of several tones of washes mixed so you can go back to them if you need the same wash. You will learn this from experience, it is nothing to worry about—just start in and play with it on the paper. If a flat wash, let it dry before applying next wash or it will run. If you wish to blend the color from dark to light, add water; if from light to dark, add black. Brush clear water over surface you wish to cover and let dry, then your wash will be smoother. Practice dozens of these exercises before trying to apply it to your drawing—you will be sorry if you don't!
Squeeze out color from brush, between thumb and finger, to pick up pools of color at bottom of wash.

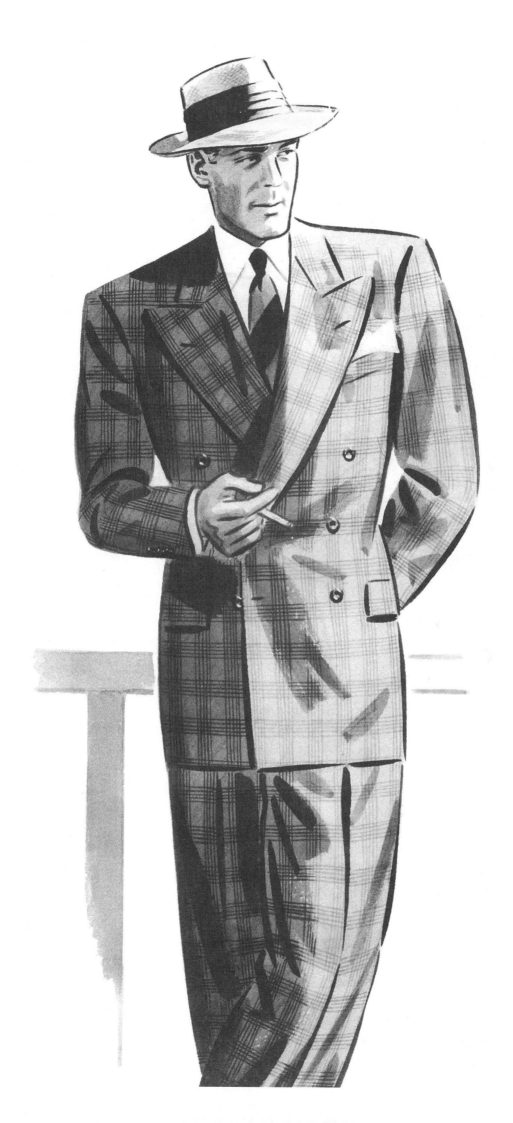

Crayon over washes, as on over-
coat and pants. Same wash applied
over the other.

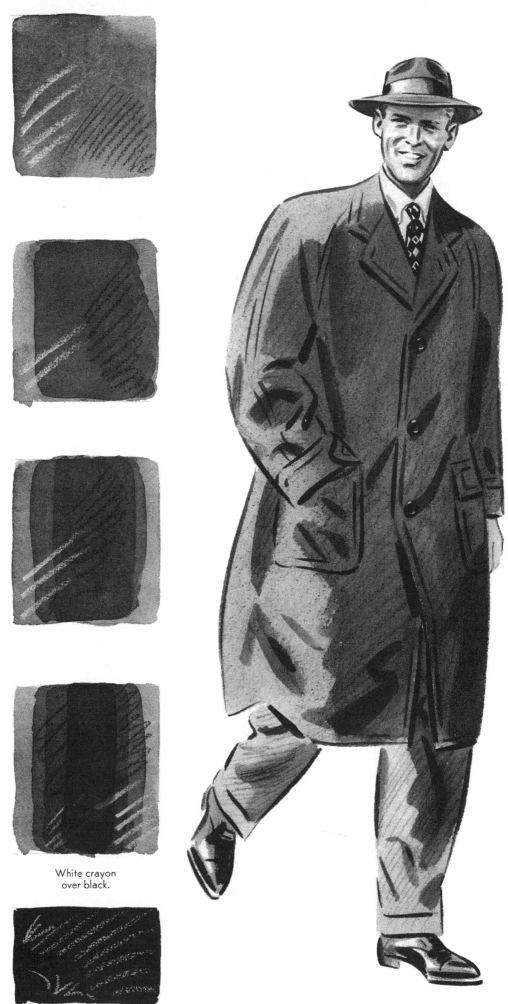

White crayon
over black.

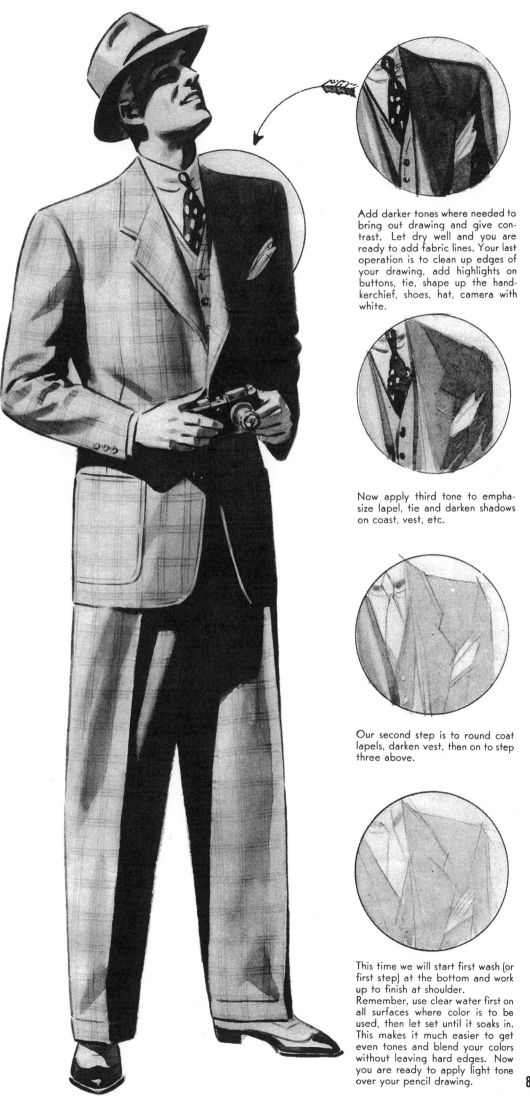

Add darker tones where needed to bring out drawing and give contrast. Let dry well and you are ready to add fabric lines. Your last operation is to clean up edges of your drawing, add highlights on buttons, tie, shape up the hand-kerchief, shoes, hat, camera with white.

Now apply third tone to emphasize lapel, tie and darken shadows on coast, vest, etc.

Our second step is to round coat lapels, darken vest, then on to step three above.

This time we will start first wash (or first step) at the bottom and work up to finish at shoulder.
Remember, use clear water first on all surfaces where color is to be used, then let set until it soaks in. This makes it much easier to get even tones and blend your colors without leaving hard edges. Now you are ready to apply light tone over your pencil drawing.

OPAQUE

The only real difference between opaque and transparent washes is the adding of white (Chinese White or a good poster white) to your black. Use poster black or black in the tube.

Opaque has its uses but also its limitations. It can be used for flat tones or on rough paper with dry brush (not much color on brush, so it just hits tooth of paper).

This gives a rough effect.

By adding white and water to your black, it will give you a creamy mixture. If applied too thick it may peel.

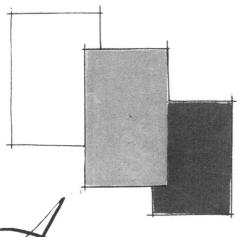

ALWAYS wash the color out of your brushes—never let it dry in them. Good brushes will last for years if you take care of them.

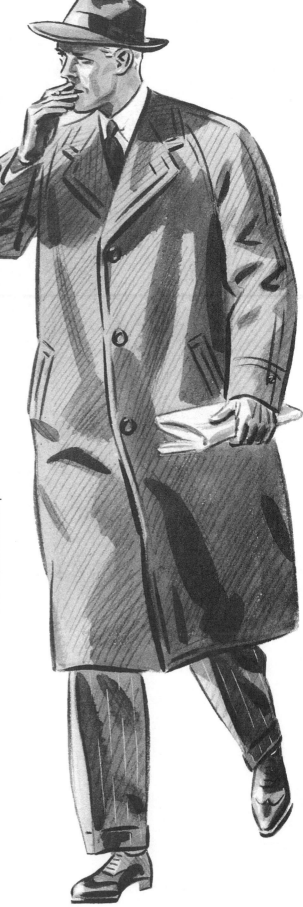

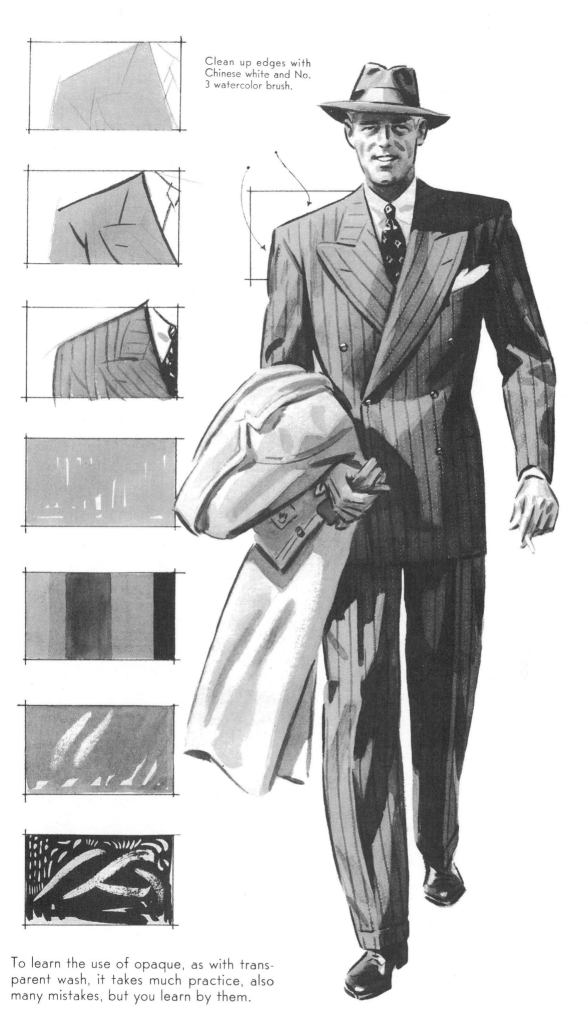

Clean up edges with Chinese white and No. 3 watercolor brush.

To learn the use of opaque, as with transparent wash, it takes much practice, also many mistakes, but you learn by them.

While opaque is used a lot, many artists prefer transparent wash. Opaque is lampblack, ivory black or any color with Chinese white added so it is creamy, yes, about the consistency of cream. Use No. 6 watercolor brush.

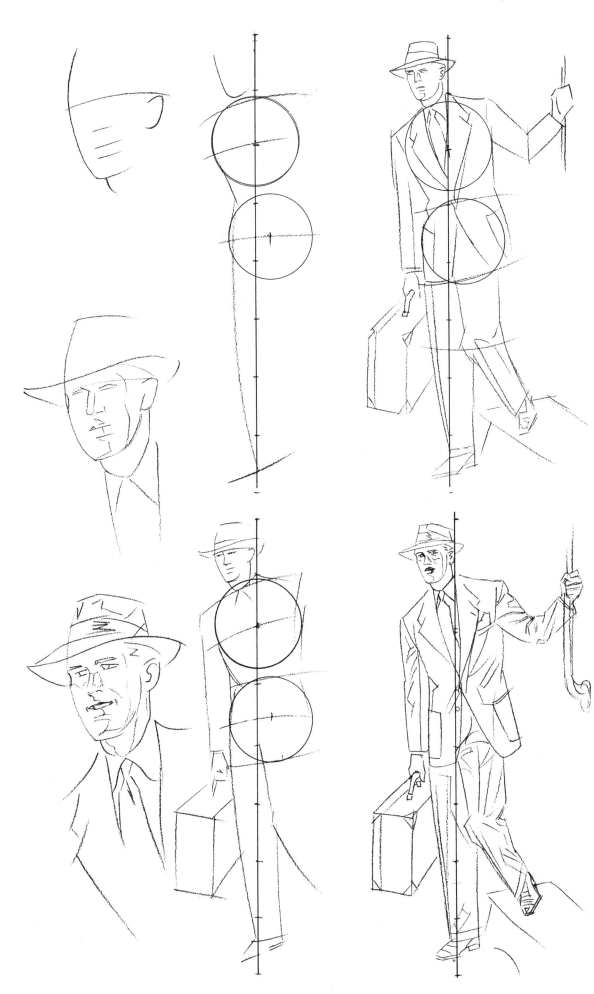

The Illustrating of Men's Fashions has always been one of the most lucrative and highly specialized branches of commercial art. It requires a good understanding of the idealistic male figure and how to drape it in a style so attractive that it creates a desire to possess the suit he is wearing.

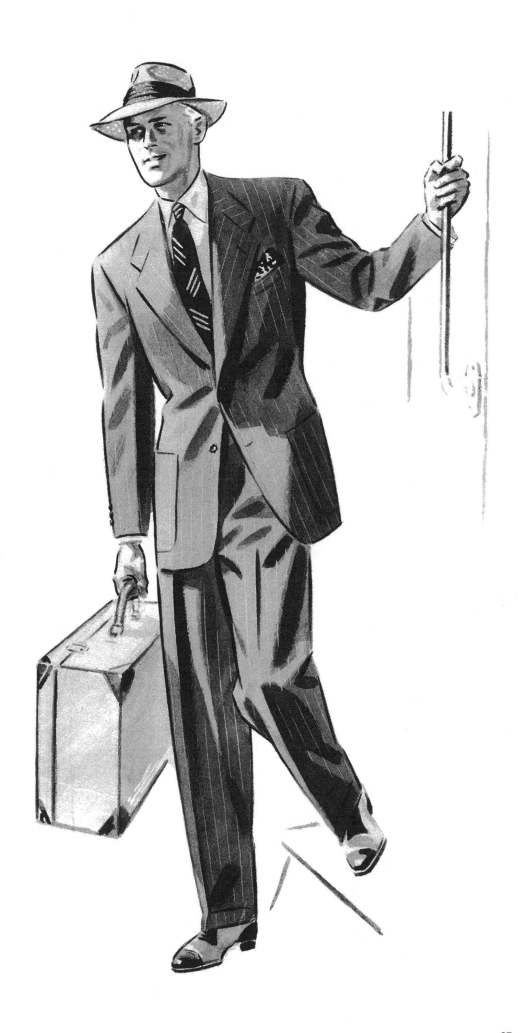

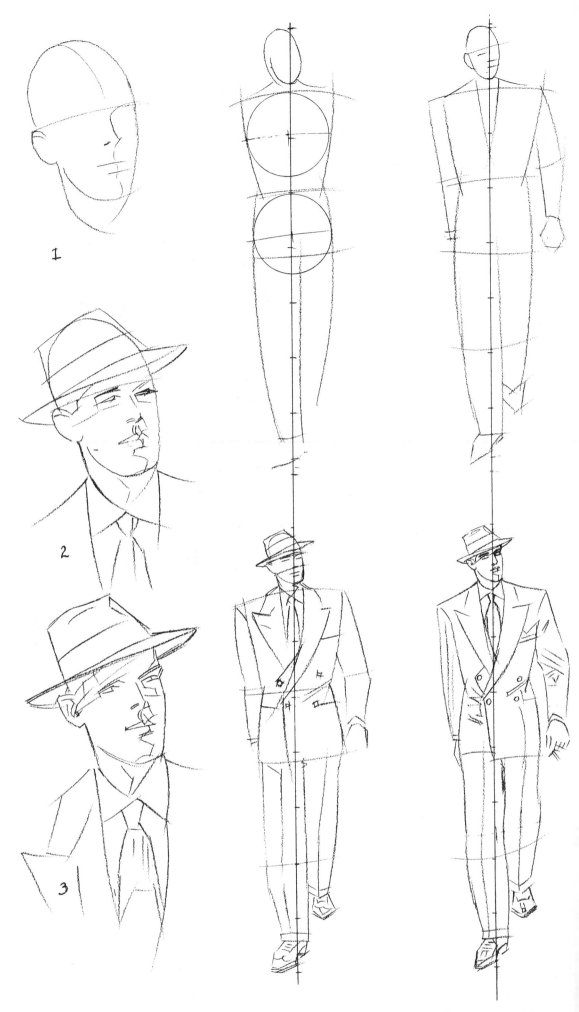

To get action into a front view figure is quite a problem even for an experienced artist, but you will note the swing of the arms (one arm in back of the body to give depth), the placement of one foot some distance back of the other, gives the appearance of action and takes care of a difficult foreshortening.

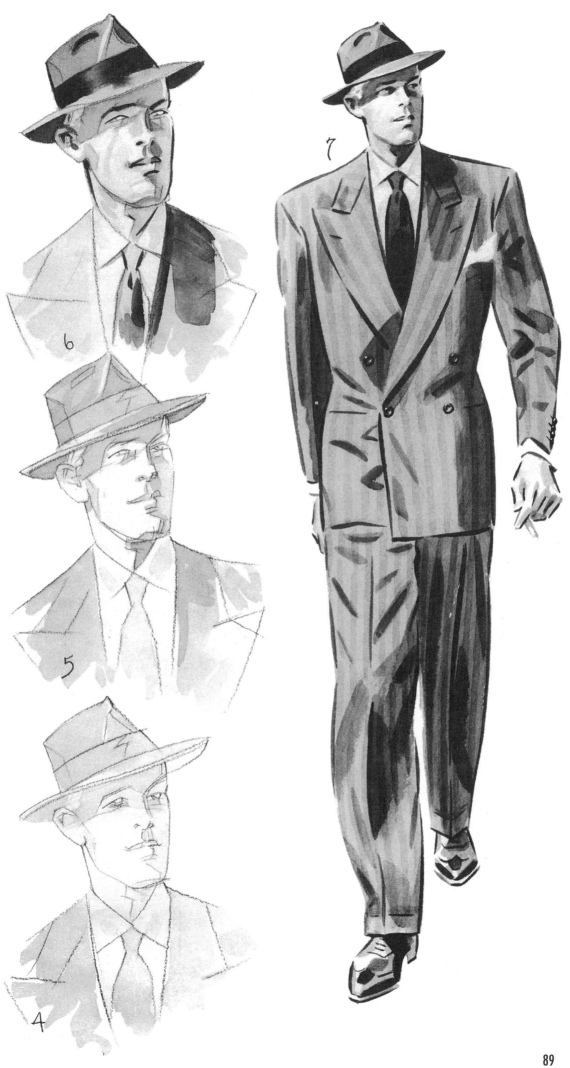

89

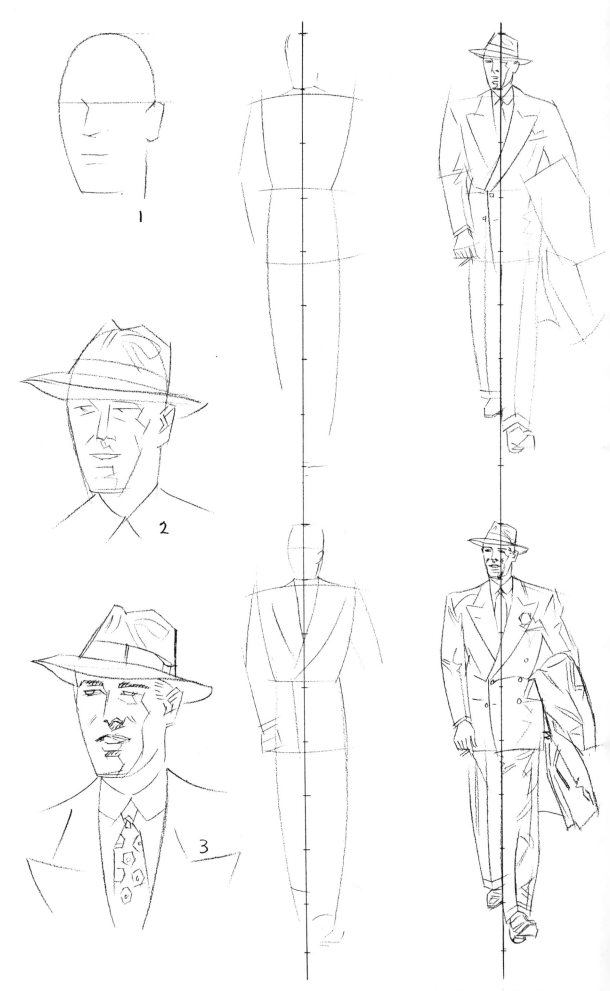

In this figure we have the left foot forward. Study this and figure on preceding page and you have two walking figures that you can use many times.

The steps in a wash drawing can be cut to few if you will think before starting. Mix up enough for your lightest wash, apply it over all parts of figure and head that is not white (leave the paper for the white as much as you can, as the white often chips off). After this dries, use same wash for next tone. For your very dark tones add more color or use out of pan. If you wish, use India ink for your solid blacks.

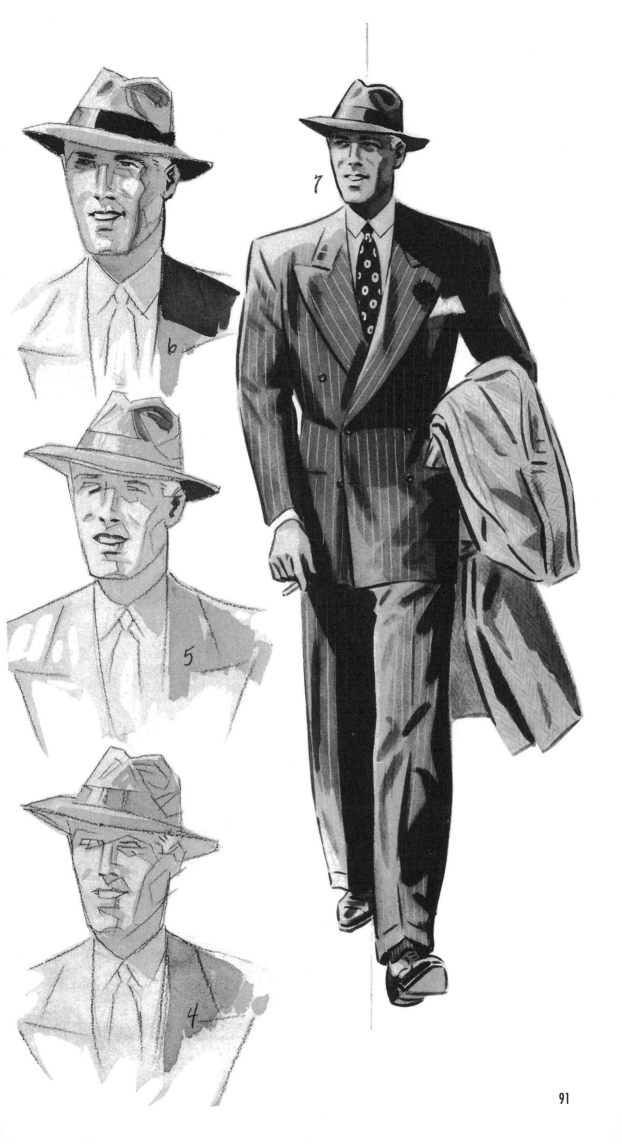

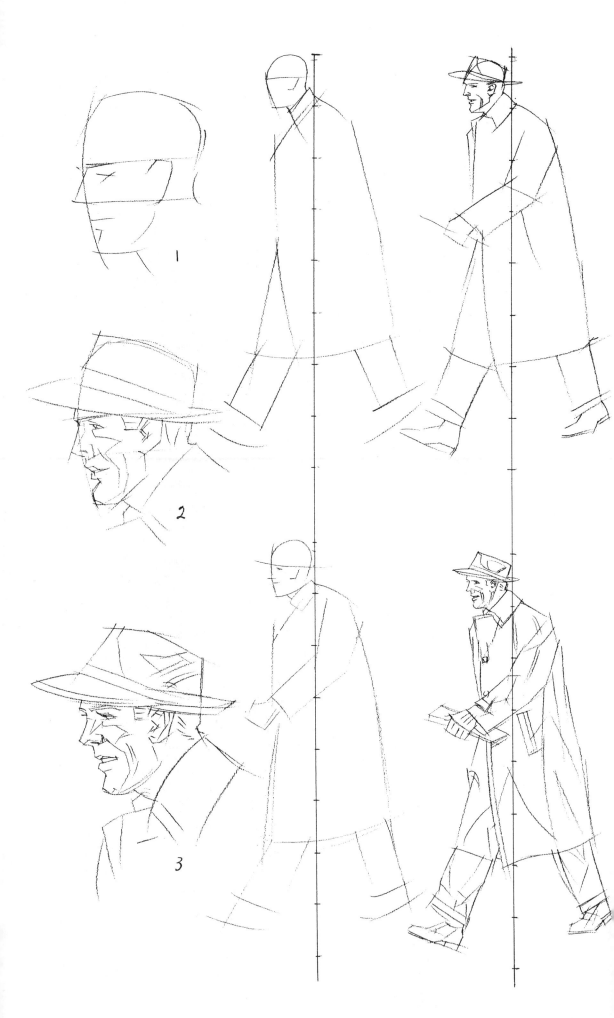

If you feel the need of more accurate measurements, use the edge of a large envelope or folded paper. Mark off eight heads, divide one space in halves, one into thirds, one into fourths, or any measurement of which you are in doubt. Use this for a rule and after doing it for a while all measurements needed will become a part of you and your eye will soon know a head, half-head, etc., without the measure.

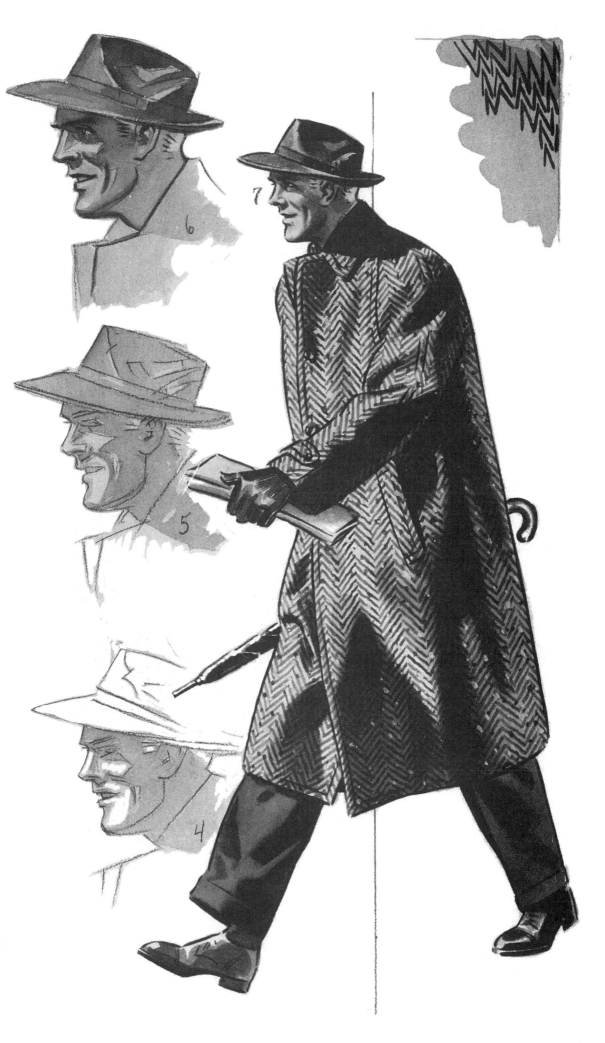

93

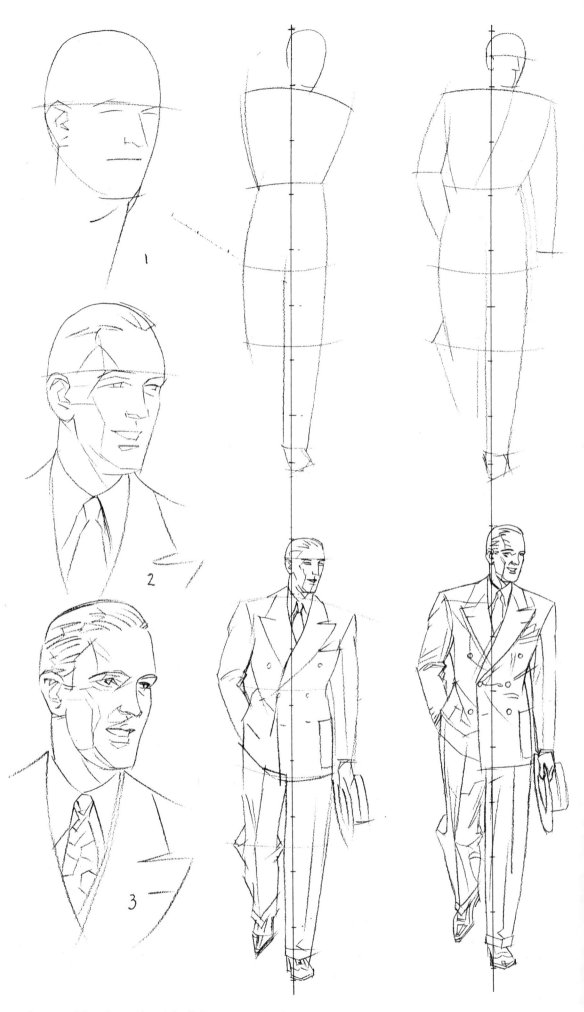

On many of these figures I have left off the 2, 4, 6, 8, also the circles. This is so that you will not lean upon them too much and have to count down to know where certain heads and half-heads come. You can learn them in an hour or so, then you will always have them. It isn't difficult; try it, I dare you!

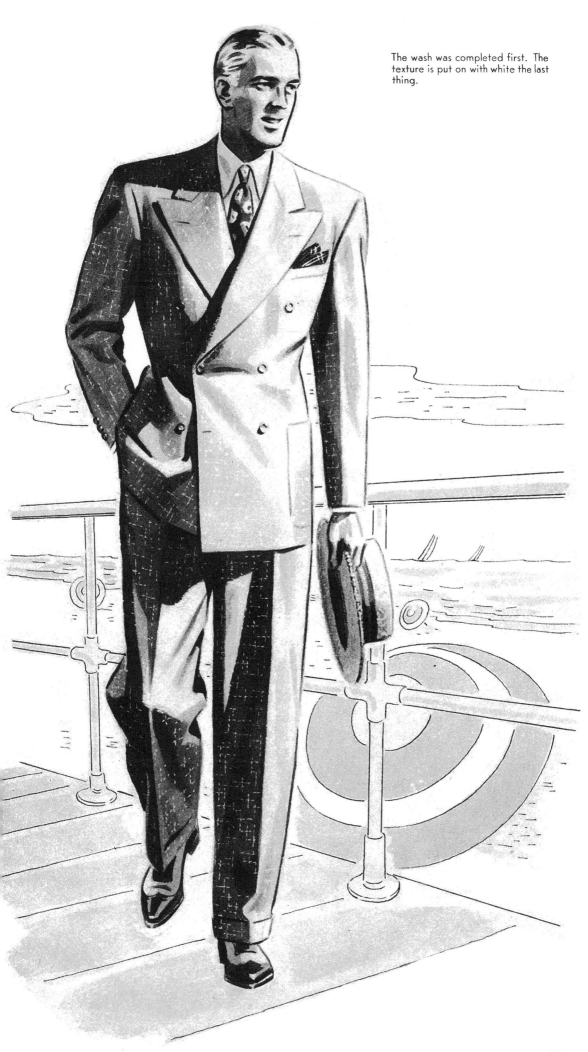

The wash was completed first. The texture is put on with white the last thing.

95

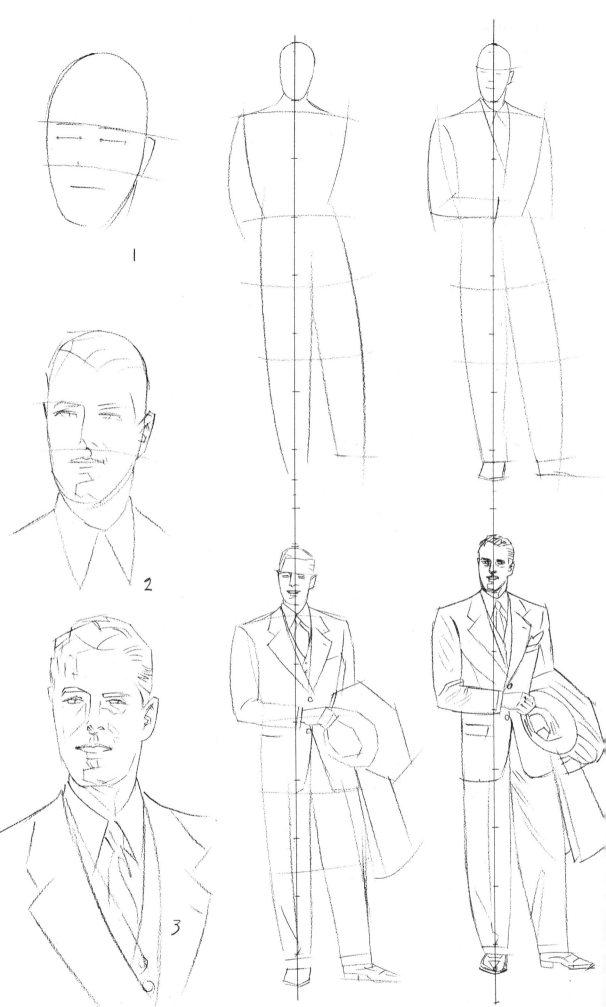

A little trick I play on myself—and it works—is to place upon my desk, just as I quit for the day, the most interesting page or drawing to be done; this gives me a good start the next morning! Another is, never to stop at a place in your work where you will hate to start again. If you do, you will try to sidetrack it and do something that is pleasant or you like to do and you will put it off for days.

Have a place to work where you will not have to put all your work and materials away. Getting them out each time has discouraged more beginners than hard problems.

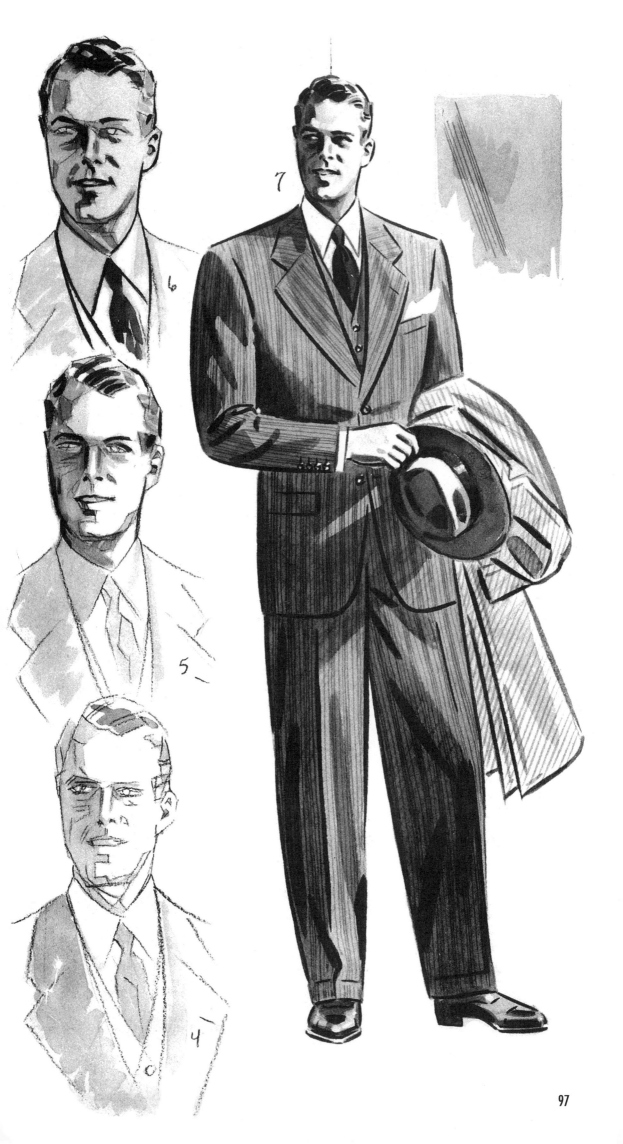

6

7

5

4

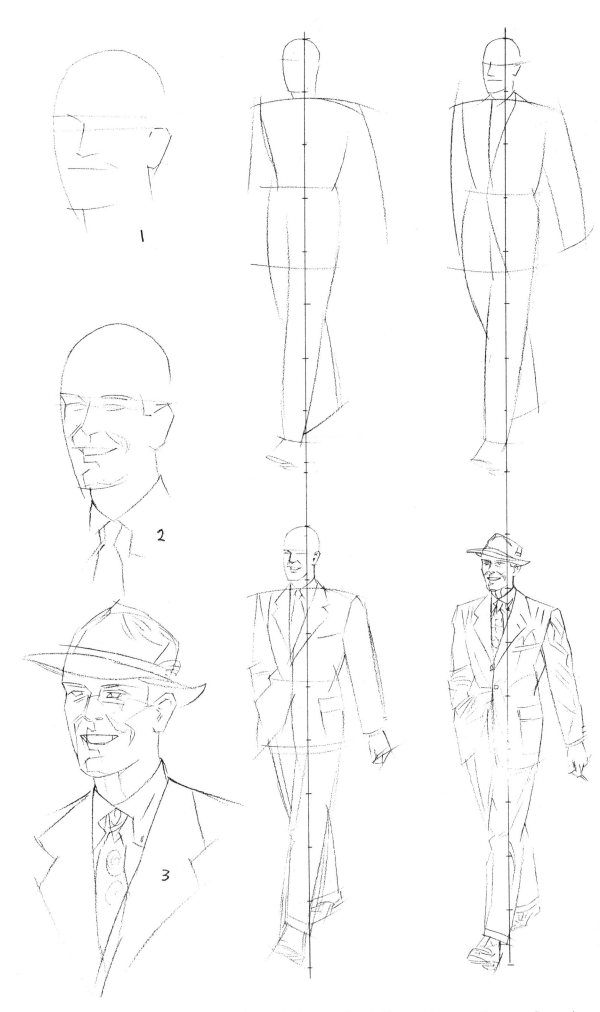

Any form of work needs a change in tempo, a change in kind or a rest from it. If your work becomes tiresome, walk around the block, read a short story, work in your garden, or do something different, then come back to it. You will find your drawing will have a new meaning as well as new interest.

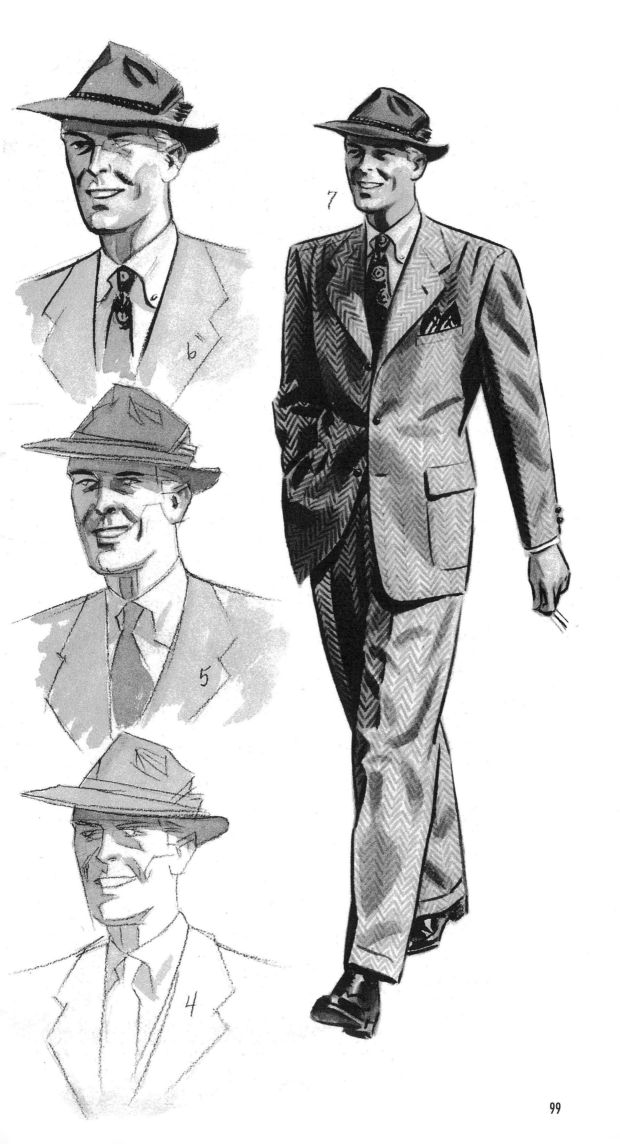

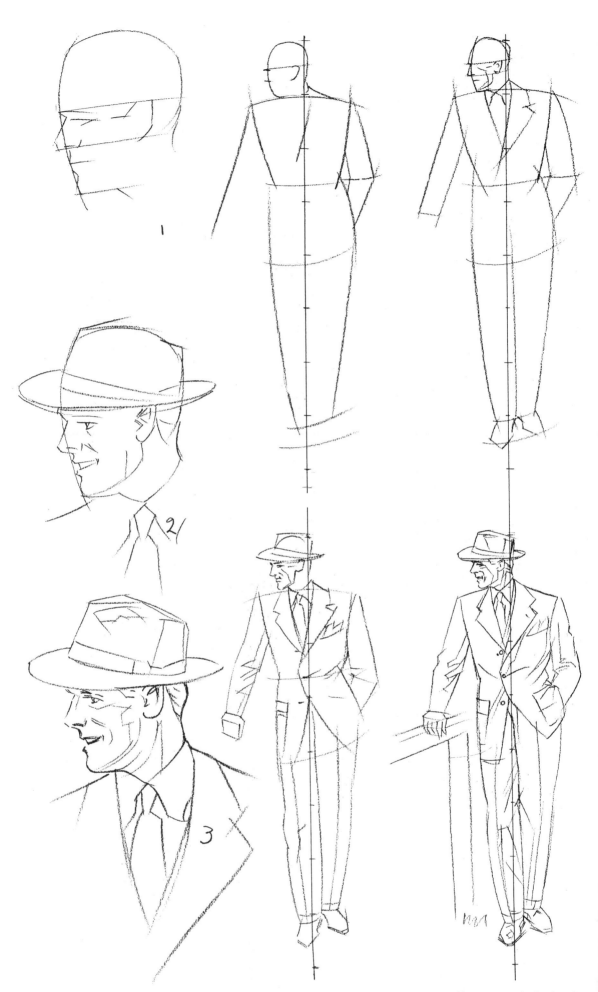

The fashion figure height will vary and you should learn to make them tall or short. The main difference is in the leg length, and, of course, the arm length must correspond. Before you are conscious of it you will have your own pet height for the figures you draw and many other little mannerisms that will creep in and later be known as "Petty style" or whatever YOUR name is. Style and individuality are developed through working out your own ideas, trying different things and effects. It isn't inherited—it is up to you.

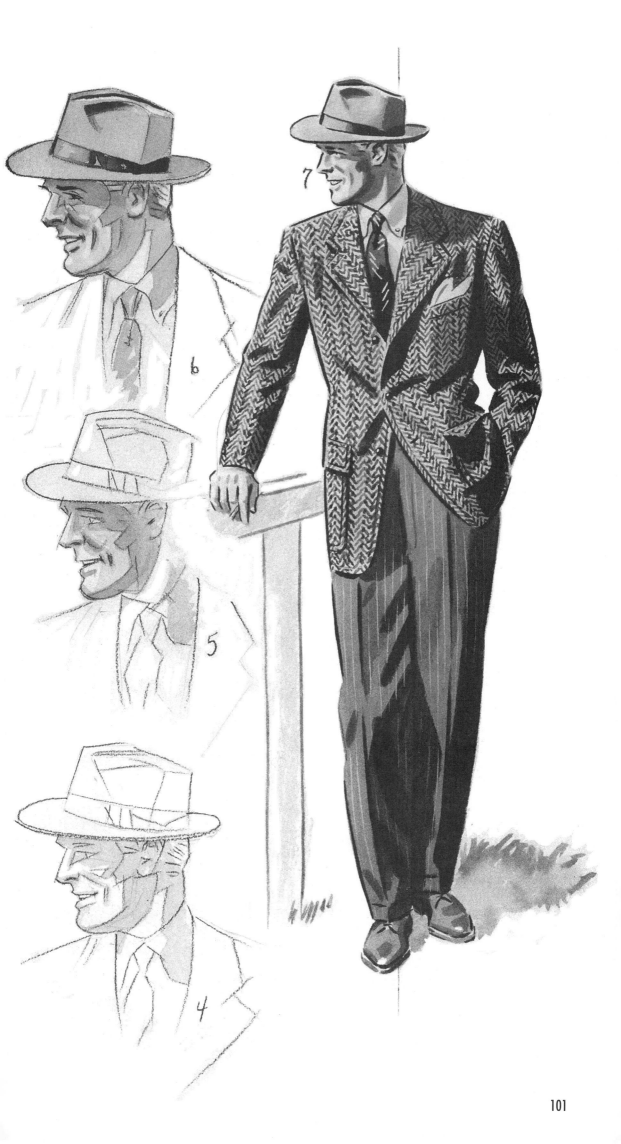

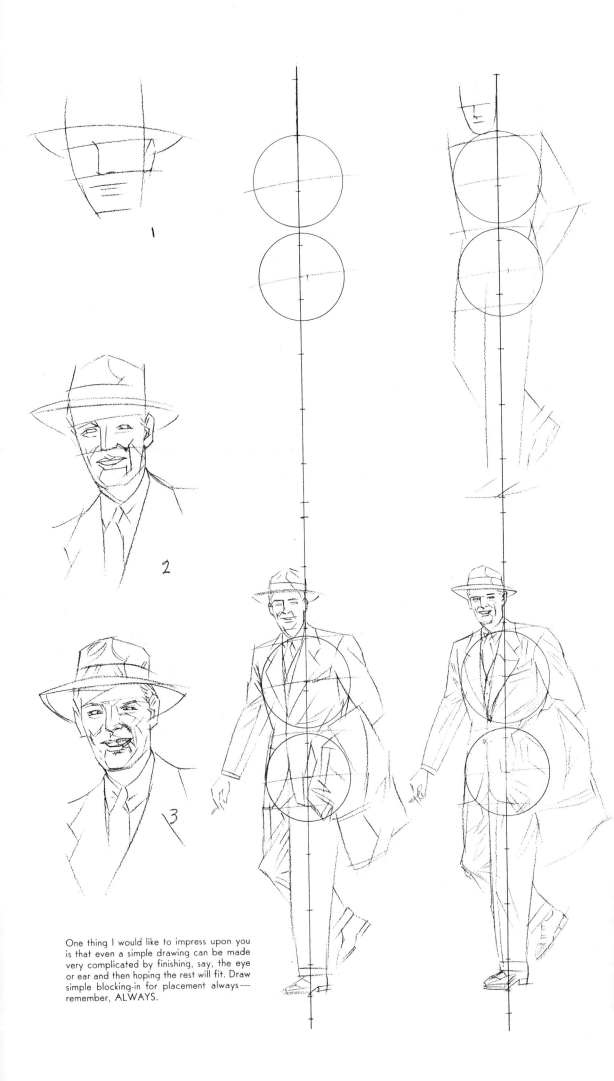

One thing I would like to impress upon you is that even a simple drawing can be made very complicated by finishing, say, the eye or ear and then hoping the rest will fit. Draw simple blocking-in for placement always— remember, ALWAYS.

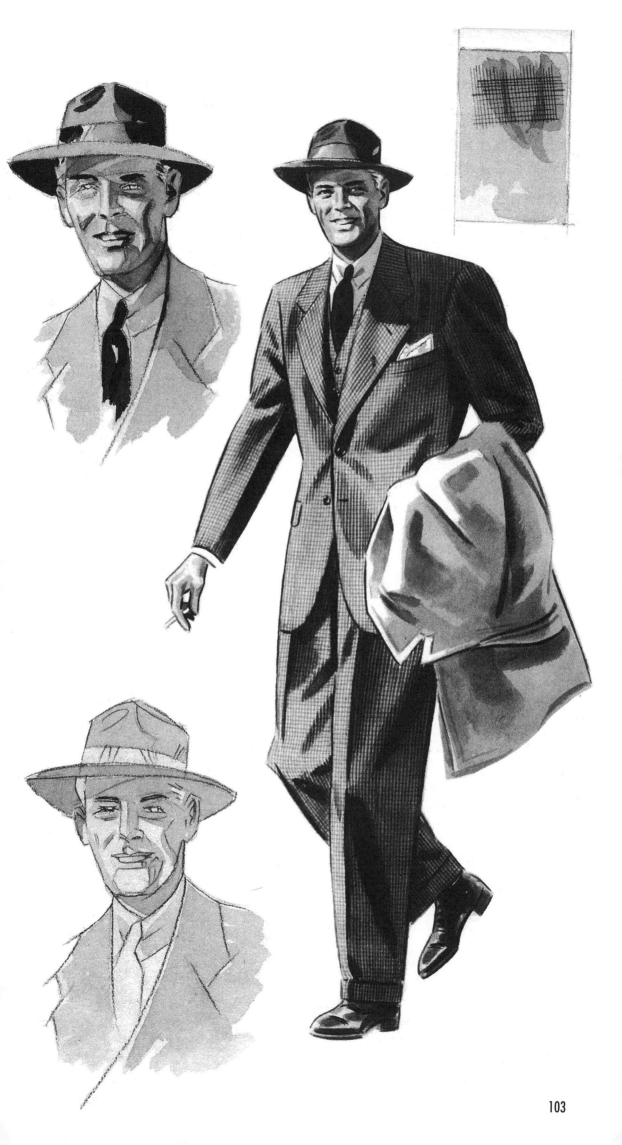

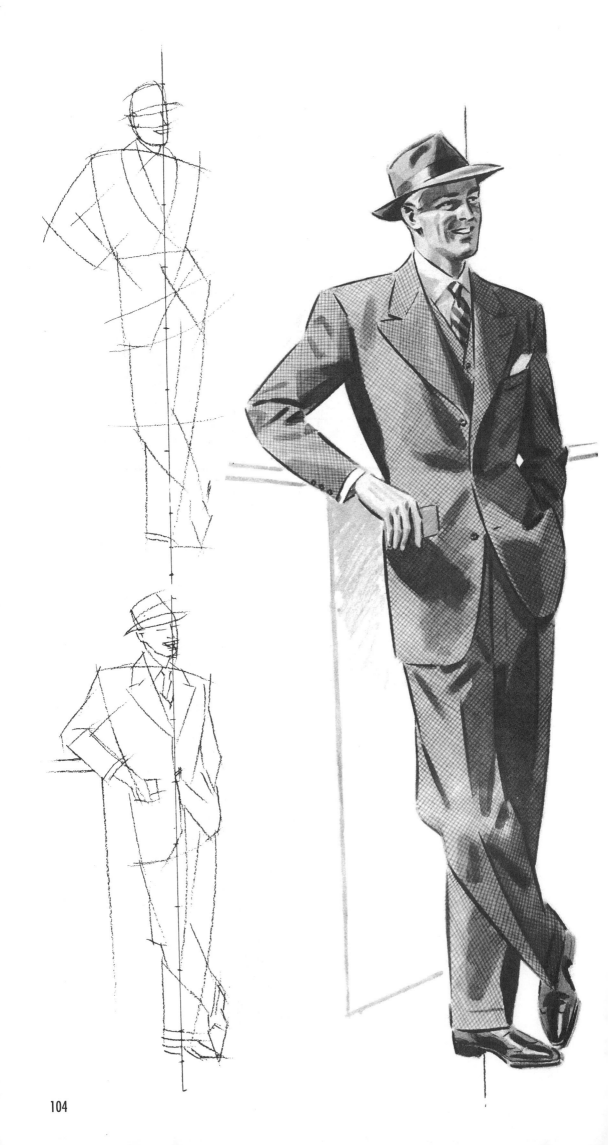

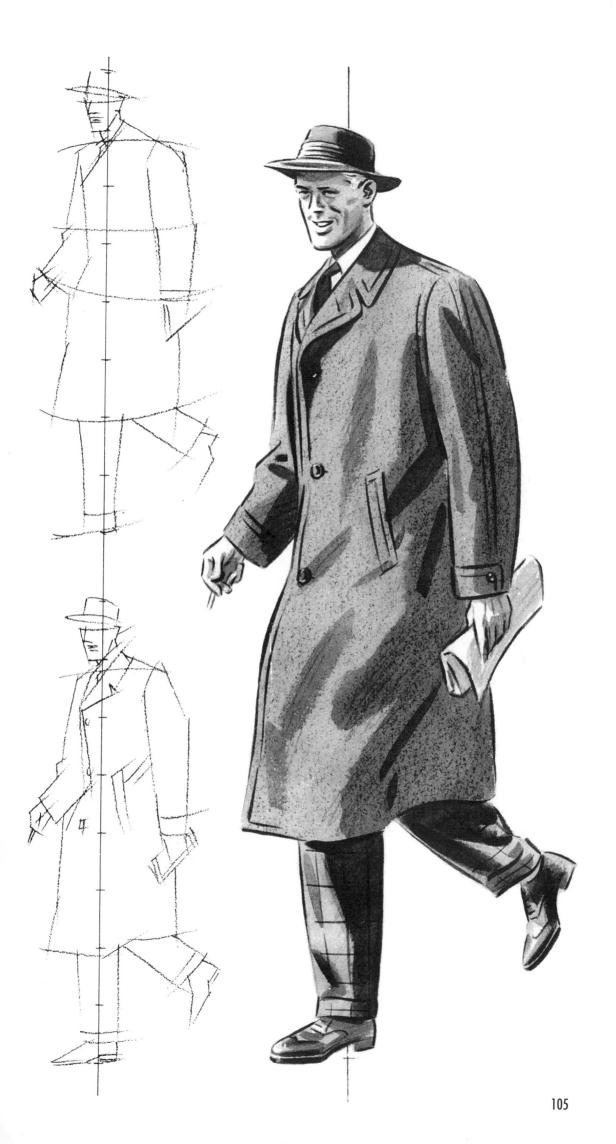

ROUGH

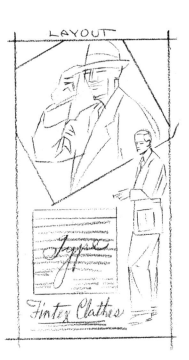

LAYOUT

The first stages of your layout is like shorthand to a stenographer—you can read it but no one else can.

After making the first one it will bring on another idea or layout and then others, but you must set the thoughts in motion, and it cannot be done by saying, "I can't think of an idea to save my neck!" If the first idea doesn't come, look through ads in the magazines or newspapers and by the time you reach the back you will have more ideas than you can put down.

*A*N IDEA is one thing, developing it and bringing it to completion is quite another, and you do not do it all. When you see an ad in a national magazine it usually represents the following procedure: The advertising men meet, together with the layout artist (an artist with ideas and capable of expressing them in few lines); then the Art Director gives out lettering to Lettering Artist, ad space to Copywriter, pen drawing to another artist and, say, large drawing of overcoat ad to you. You will be given layout showing size and shape your drawing will occupy (in this case 5"x5"), then you make your drawing; if in wash, about 10"x10"; if in oil, 14"x14" or larger. By the time you are this good you will have your own pet brushes, canvas, paints and know the size at which you work best. Not only that, the ones you work for will be more conscious of your little pet whims than you are—only they will call it temperament and, of course, they also have more forceful words for it—Ha, Ha! However, if your work is in demand, you will find it pays well, is a very pleasant and interesting profession and that it is not wise to be too temperamental.

If you do not know about reproduction, the overcoat ad on the right-hand page is an 85-line highlight halftone for newspaper (85 dots to the running inch or 7225 dots to the square inch). Other wash drawings in this book are 133-line halftone screen (17,689 dots to the square inch).

Space will not permit explanation of reproduction in full, but hope to have a book out on it one of these days.

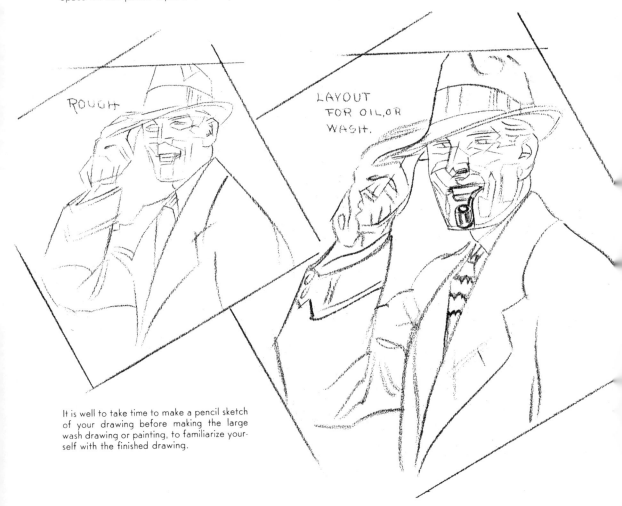

ROUGH

LAYOUT FOR OIL, OR WASH.

It is well to take time to make a pencil sketch of your drawing before making the large wash drawing or painting, to familiarize yourself with the finished drawing.

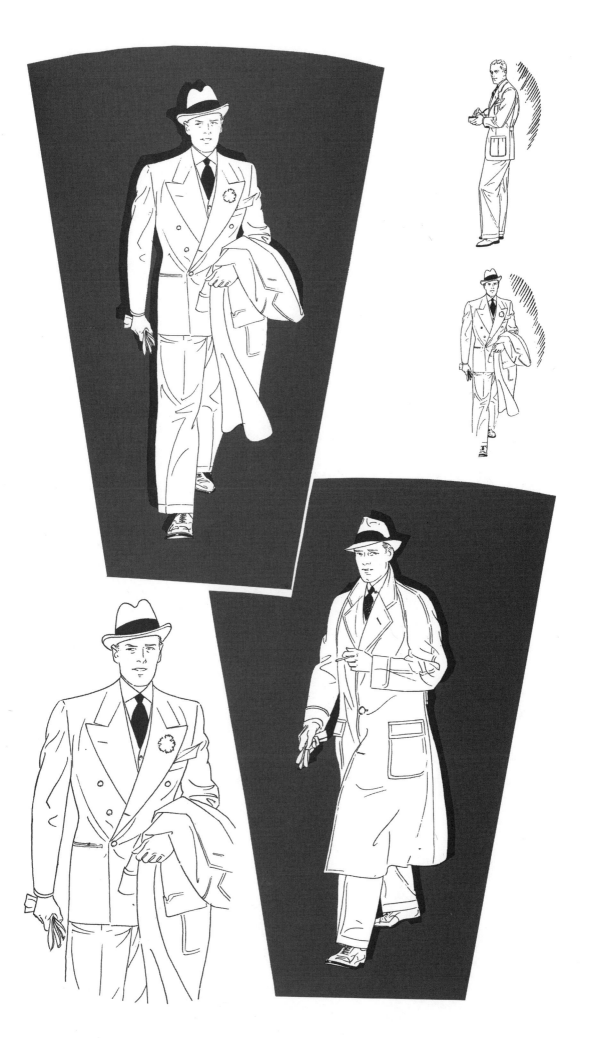

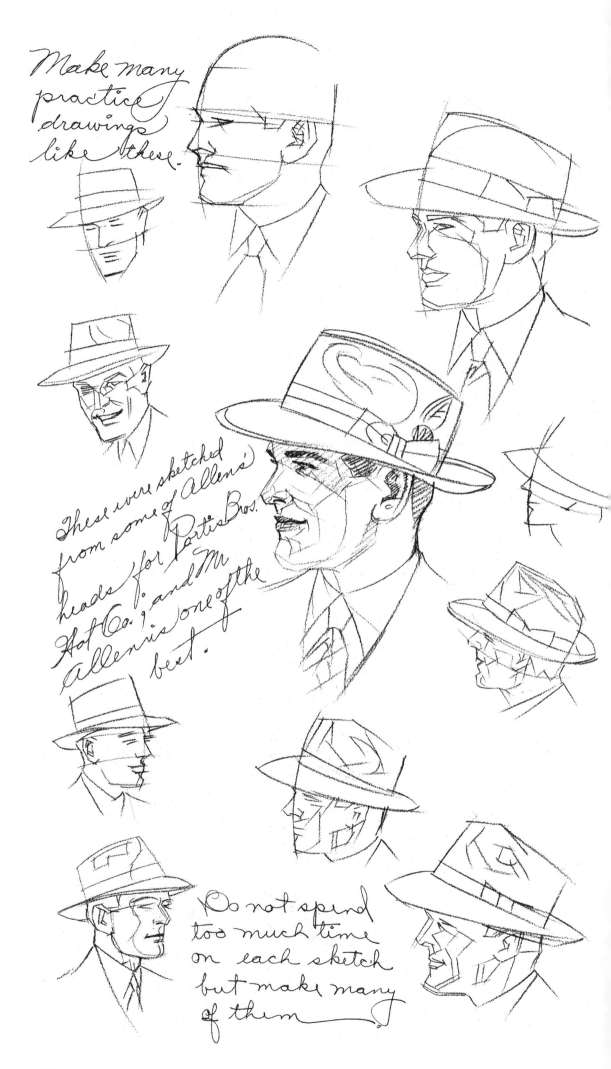

Make many
practice
drawings
like these.

These were sketched
from some of Allen's
heads for Portis Bros.
Hat Co., and Mr
Allen is one of the
best.

Do not spend
too much time
on each sketch
but make many
of them

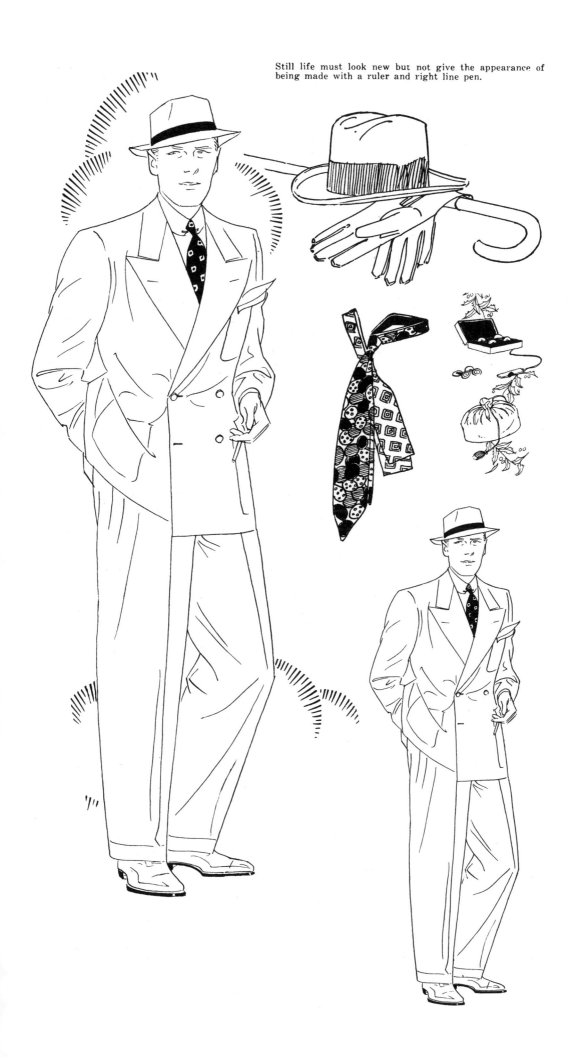

Still life must look new but not give the appearance of being made with a ruler and right line pen.

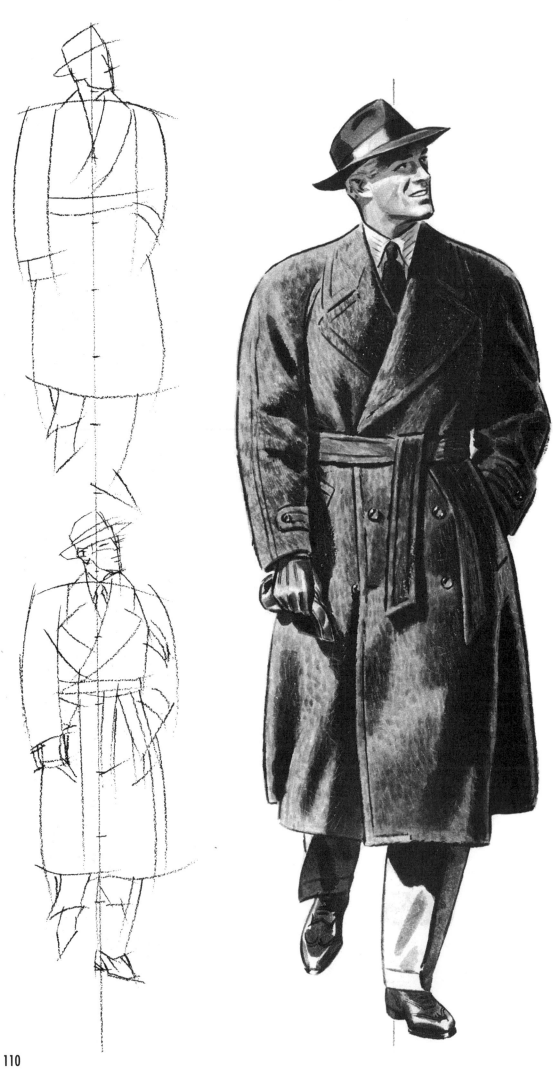

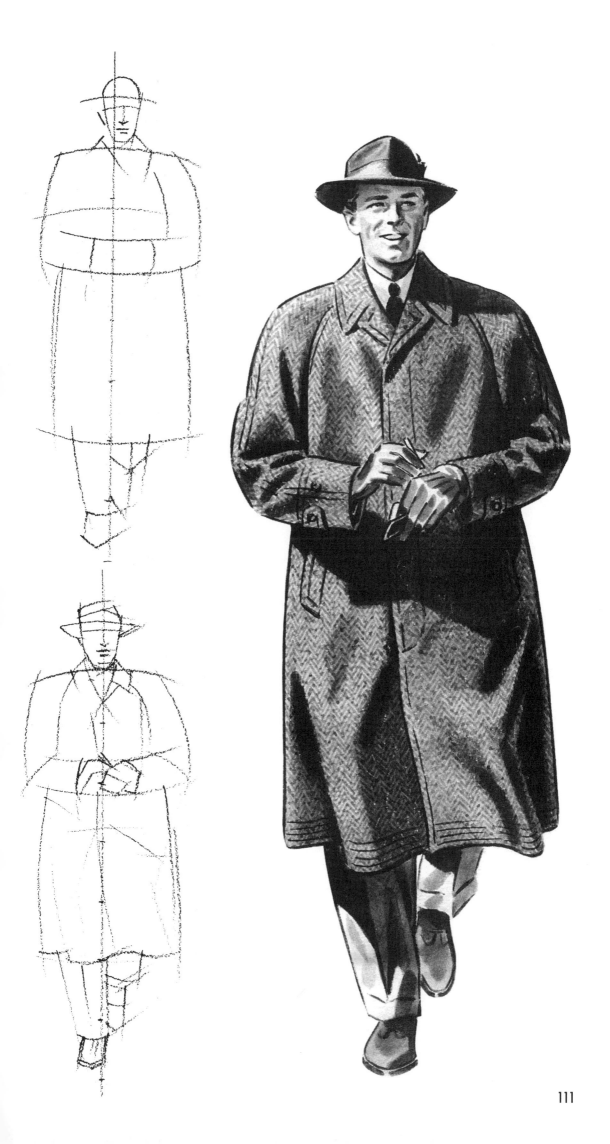

How to Draw the Figure: Male Fashion
Part II

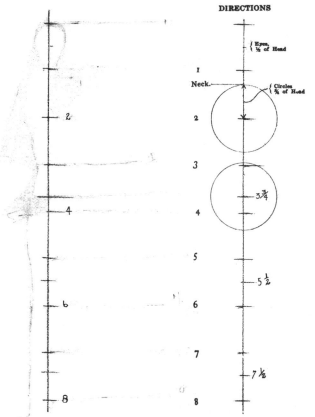

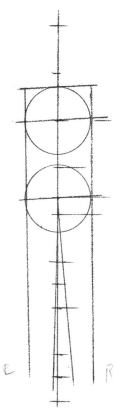

Draw vertical line, divide in eight heads, mark off 2-4-6-8. Divide the second head in fourths. ¾ will give you neck line.

Place compass point on 2, extend to neck line—this will give you size of circle. If you want a more slender figure make circles smaller.

Draw line touching sides of circles and lines for shoulders and hips. If the figure is standing on right foot, the right hip will go up and the right shoulder down. Center of circle moves to right of line of balance.

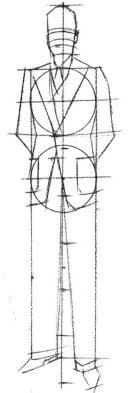

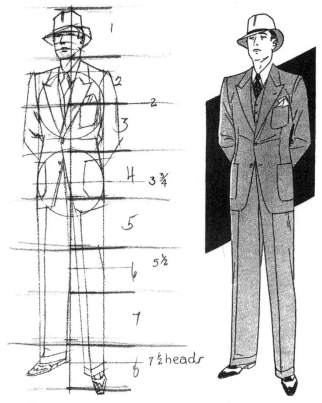

Draw lines for body, add the arms. Remember the elbows are at 2¾ head on male figure. The knees are at 5½ heads and heels at 7½ heads. Draw lines for neck. Then draw eye and chin line. My book on "How to Draw the Head" will give you the details on heads.

Add hat, shape up shoes, pockets, coat lapels, head, etc., and proceed with the inking in.

Center of neck and center of ankle will always be on the line of balance (or vertical line) unless figure is standing on both feet or in action. This figure was made with 170 pen point and the black added with No. 3 brush.

A WORD TO THE PROFESSIONAL AND ADVANCED STUDENT. If you have trained your eye to divide and judge distances, study charts and draw line of balance free hand. Visualize circles and proceed with drawing. If you have a fixed space to place figure draw line of balance marking where you want top of head and feet to come to. Divide in half which will be four heads. Divide upper half which will be two Swing lower circle from side to side for action. See directions in my book "How to Draw the Figure." (Female fashions.)

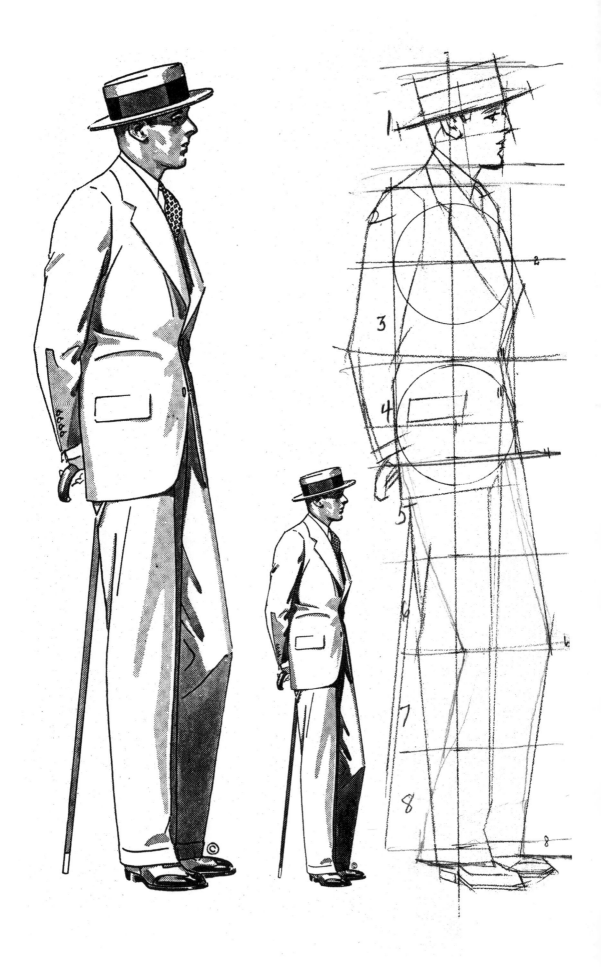

On side view the circles are smaller. Place compass point on chin line, extend to
eyebrow. This will give you half the diameter of the circle.

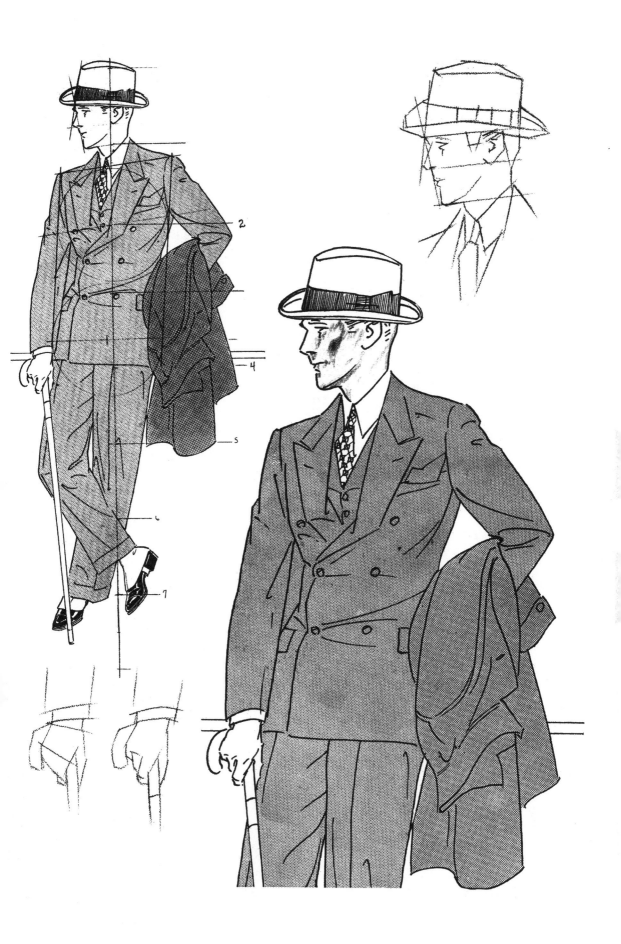

Do not confuse this drawing with the one on the opposite page. The outlines are made the same but you use blue crayon or blue watercolor to show where you want the tones. Blue will not photograph but it will show the engraver where you want "Ben Day" or tones. As I write this I can see a great need for a book on how to make your drawings for reproduction. I will start on this soon.

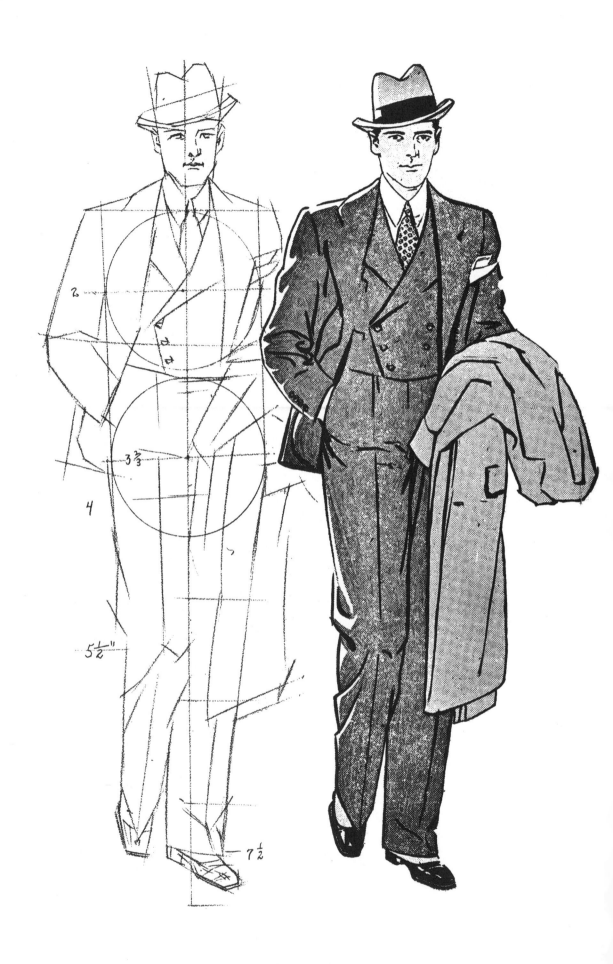

The solid blacks are made with India ink; hat, face and overcoat with transparent wash and suit with opaque wash. The original drawing was 20 inches, more than twice the size of the one you see here.

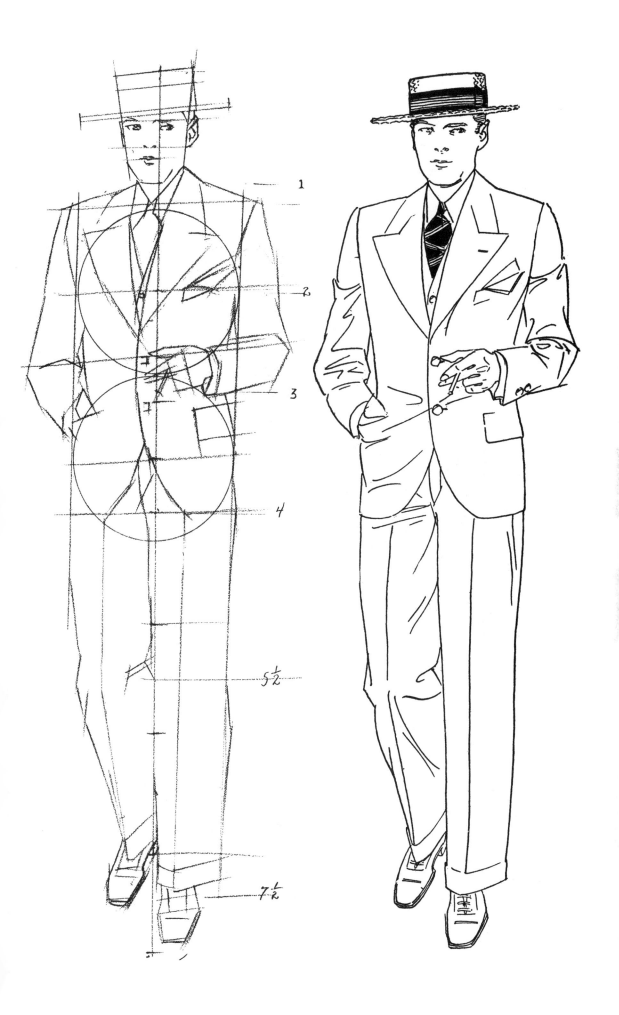

1

2

3

4

$5\frac{1}{2}$

$7\frac{1}{2}$

See Direction Sheet

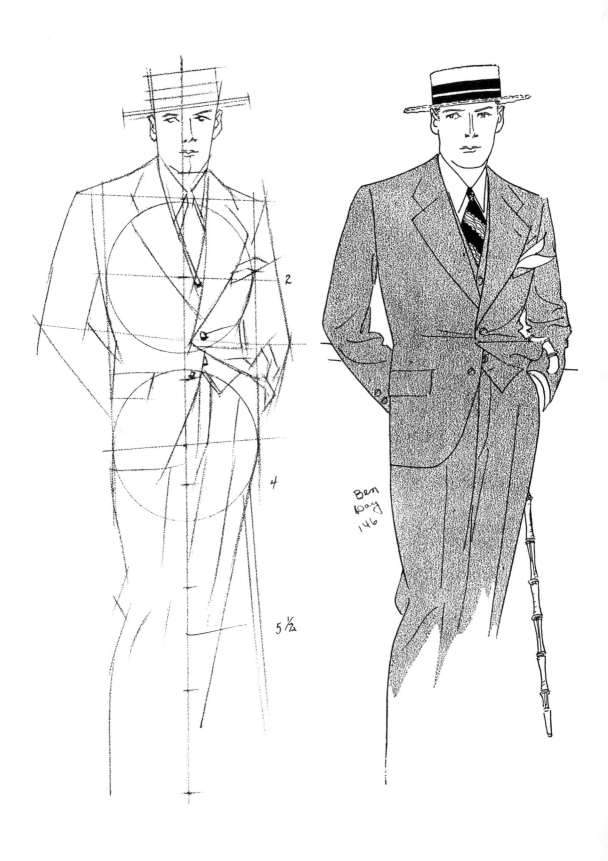

2

4

5 ½

Ben
Day
146

All engraving houses have charts showing the different Ben Day patterns (they give them to artists for whom they make cuts). Each pattern has a number. You make the outline drawing, using blue to show where you want tone and number to show tone (Ben Day) to be used.

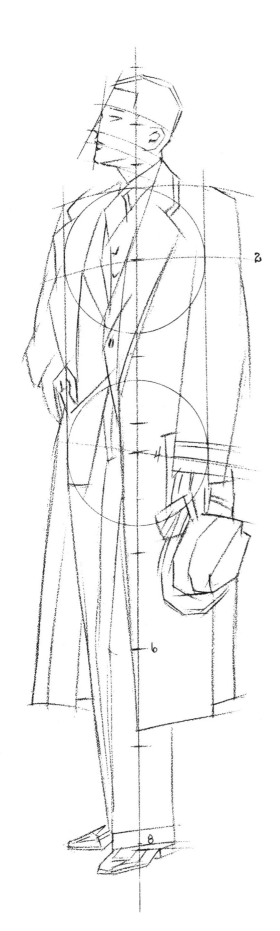
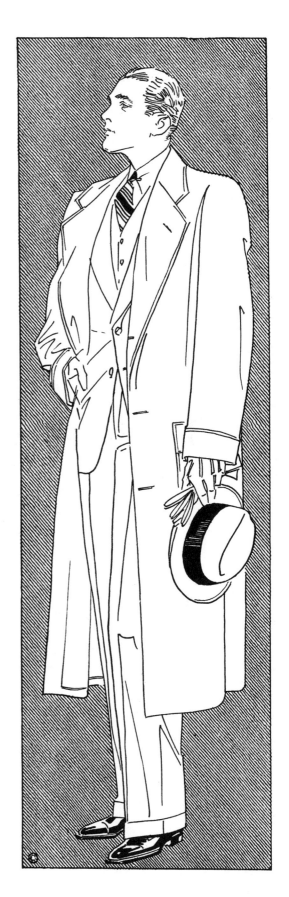

See Direction Sheet

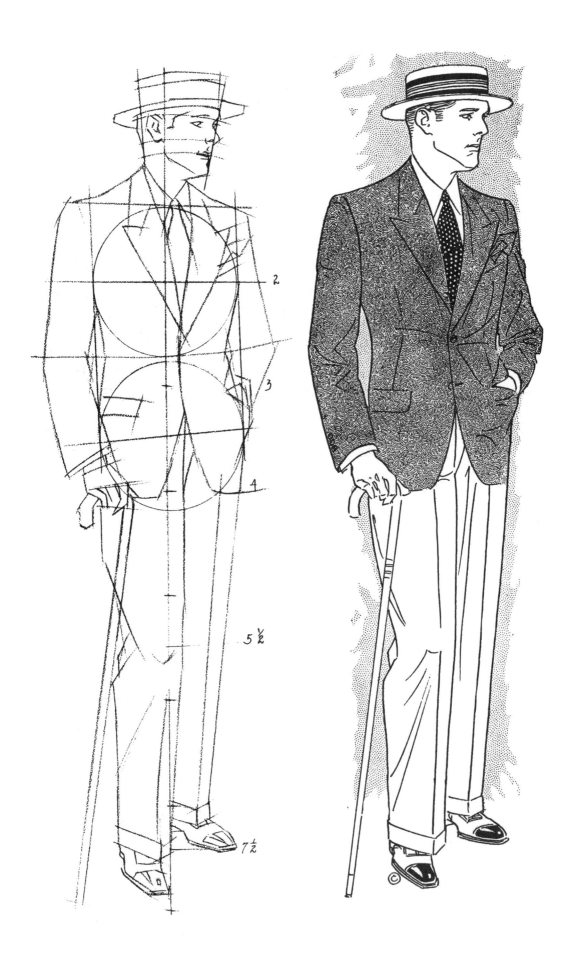

2

3

4

5 $\frac{1}{2}$

7 $\frac{1}{2}$

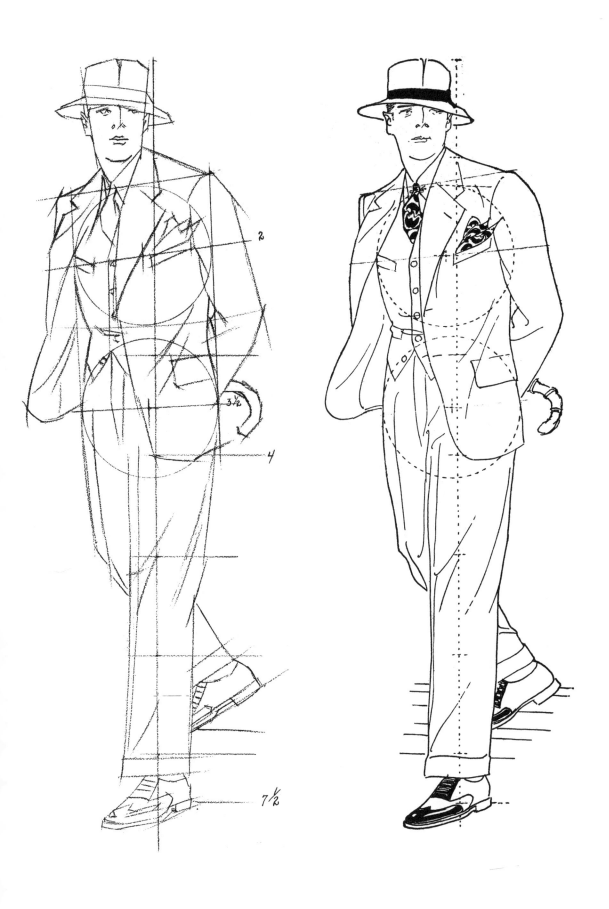

2

3½

4

7½

See Direction Sheet

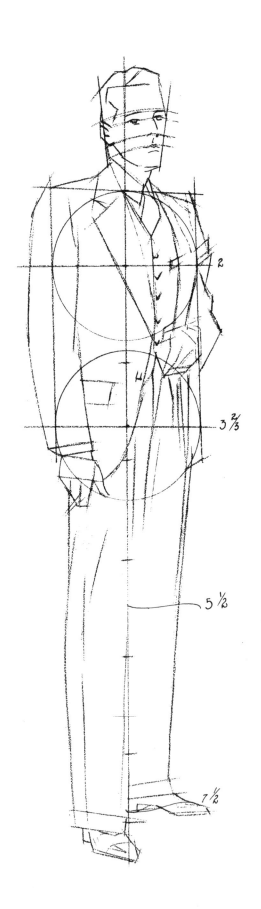

2

3 2/3

5 ½

7 ½

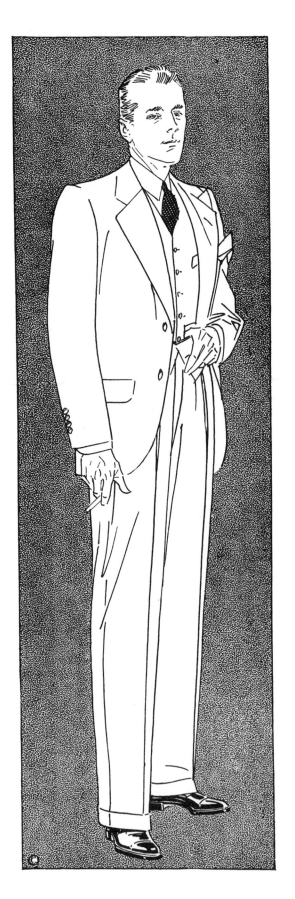

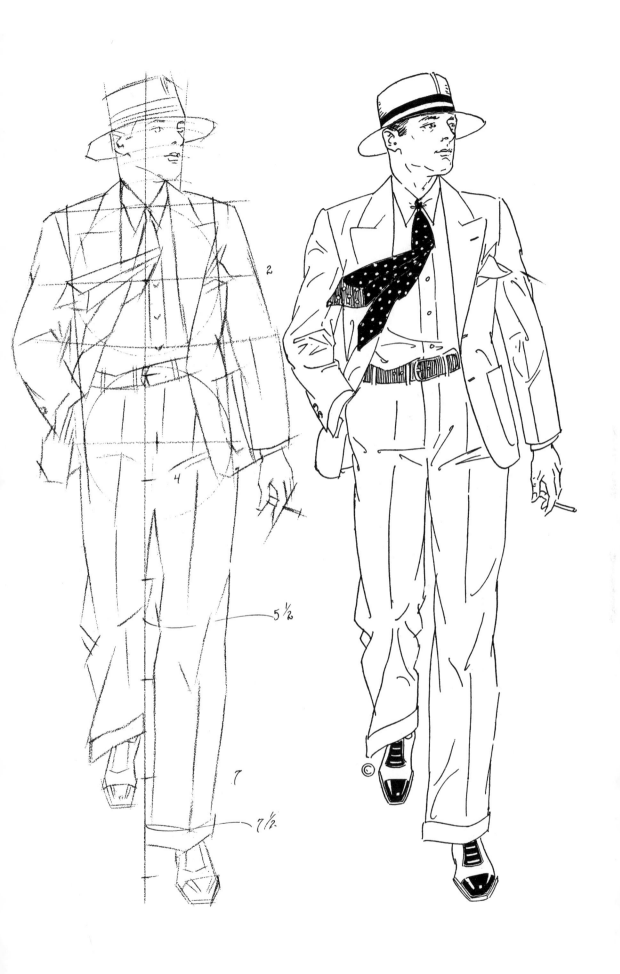

2

4

5 ½

7

7 ½

125

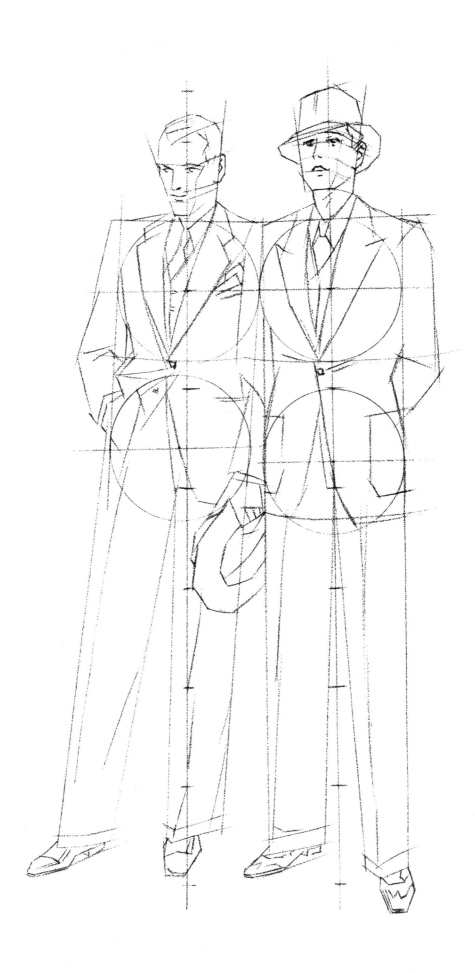

See Direction Sheet

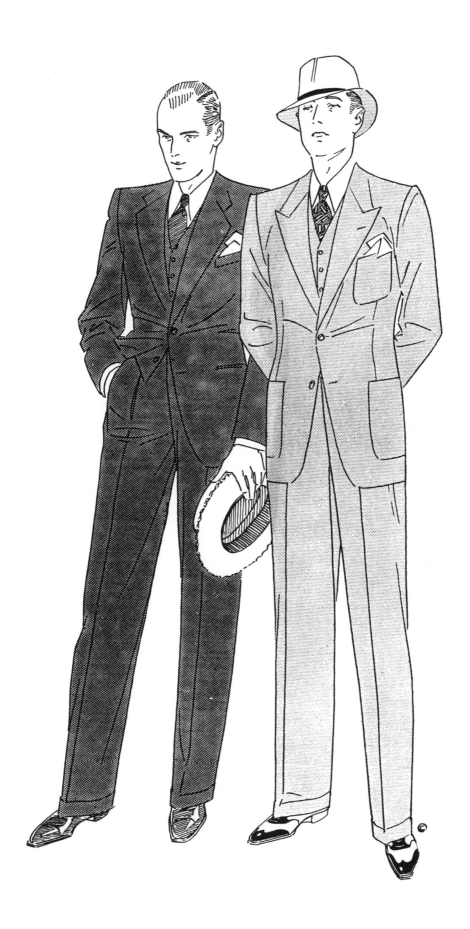

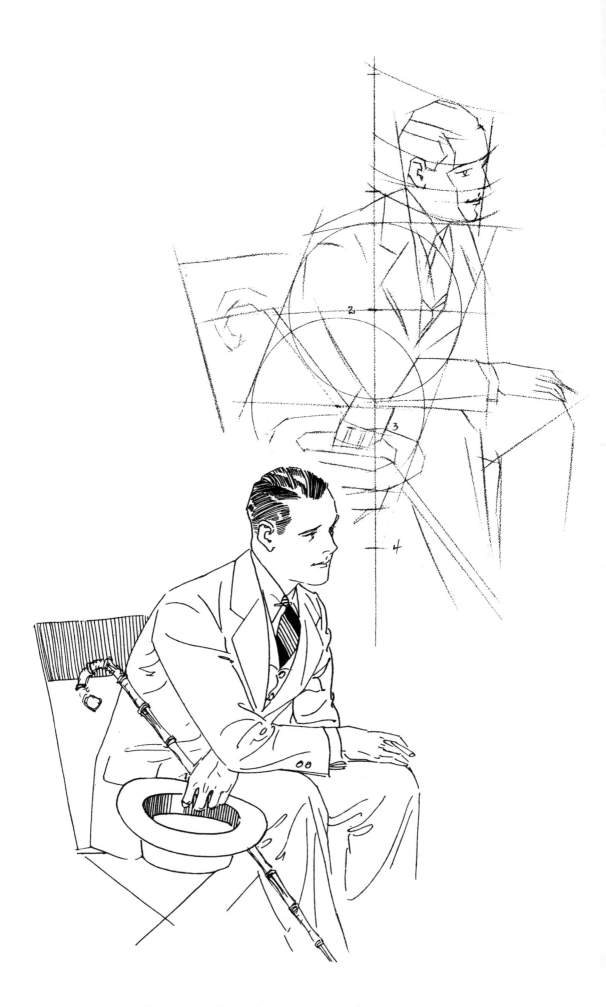

Foreshortening of this sort is advanced work, even artists that
have been at the work for years have trouble with it. I would
suggest to learn the straight views and good blocking in first,
then foreshortening will come easier to you.

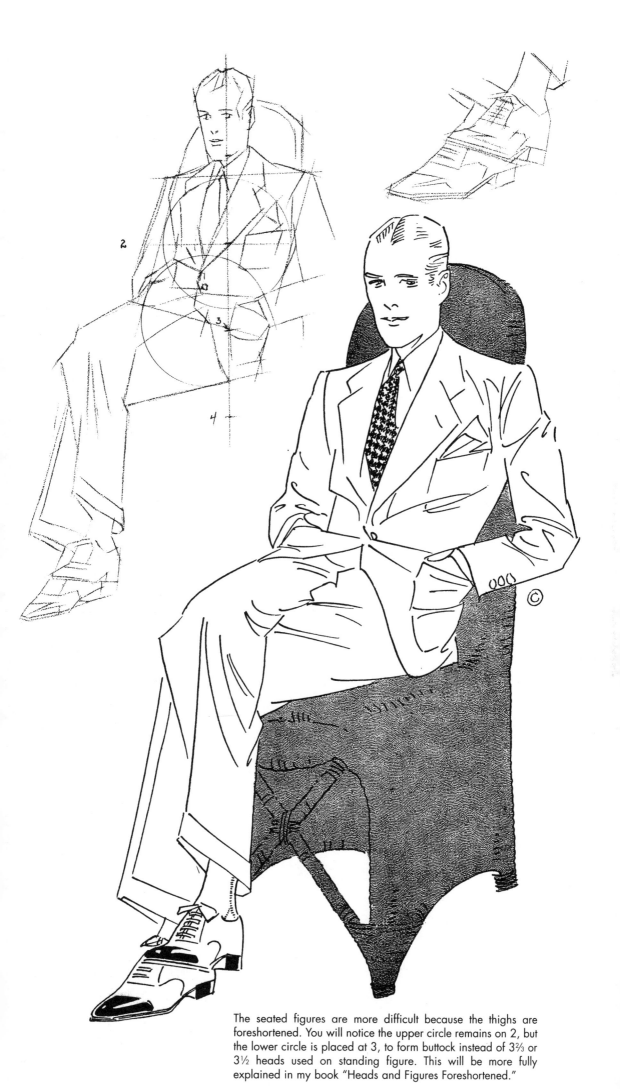

The seated figures are more difficult because the thighs are foreshortened. You will notice the upper circle remains on 2, but the lower circle is placed at 3, to form buttock instead of 3⅔ or 3½ heads used on standing figure. This will be more fully explained in my book "Heads and Figures Foreshortened."

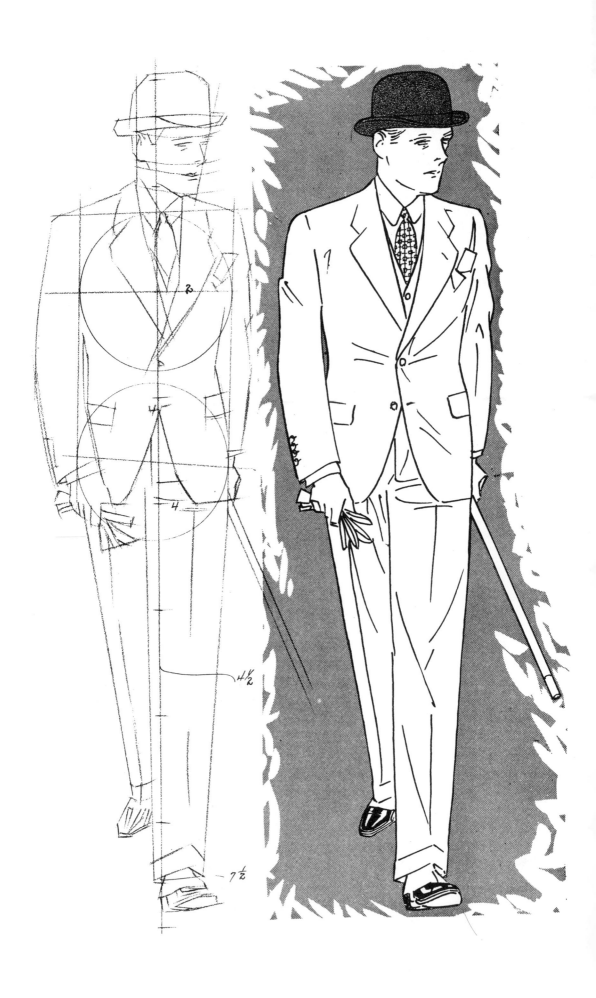

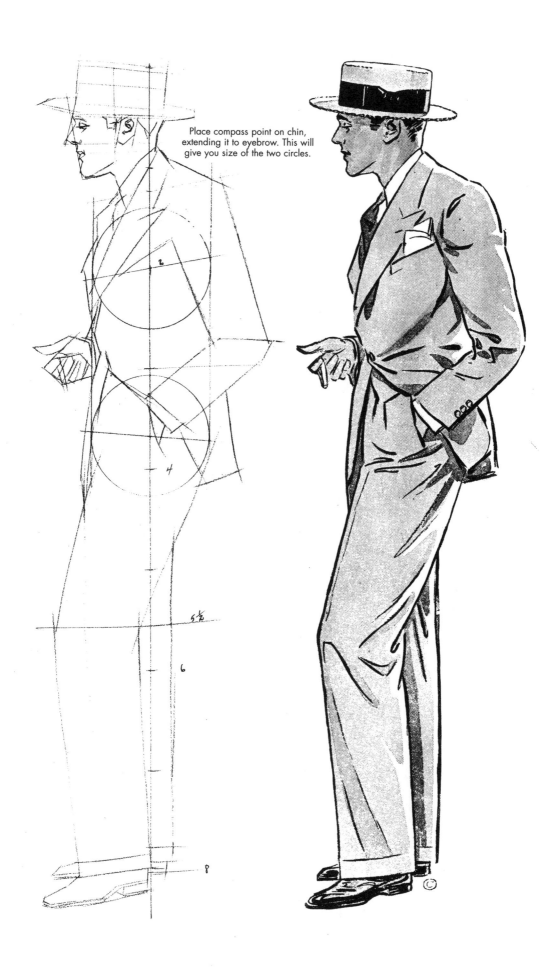

Place compass point on chin, extending it to eyebrow. This will give you size of the two circles.

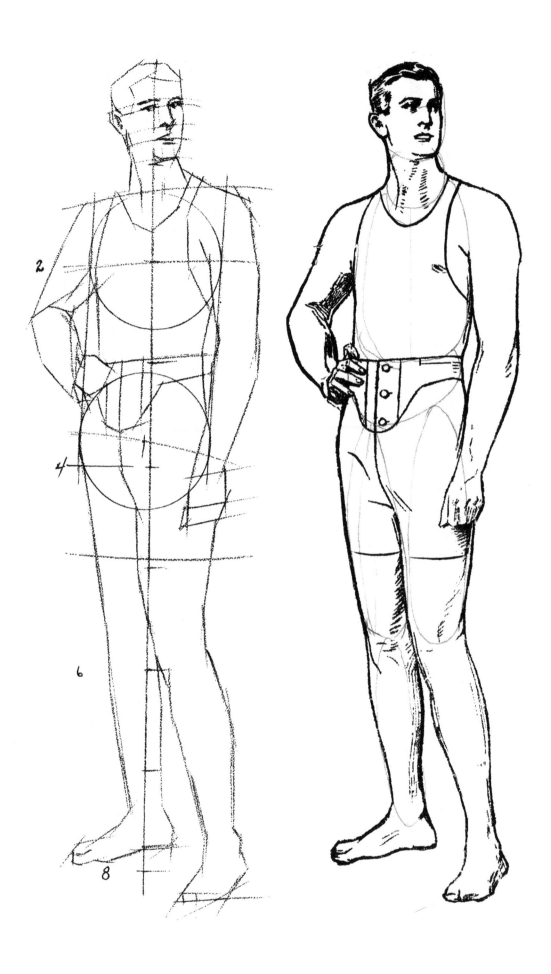

The male figure changes with the styles the same as the female figure, but the changes are not so radical. It is very easy to change the figure by reducing or enlarging the circles. Some artists are making the hips smaller this year, as shown in this figure.

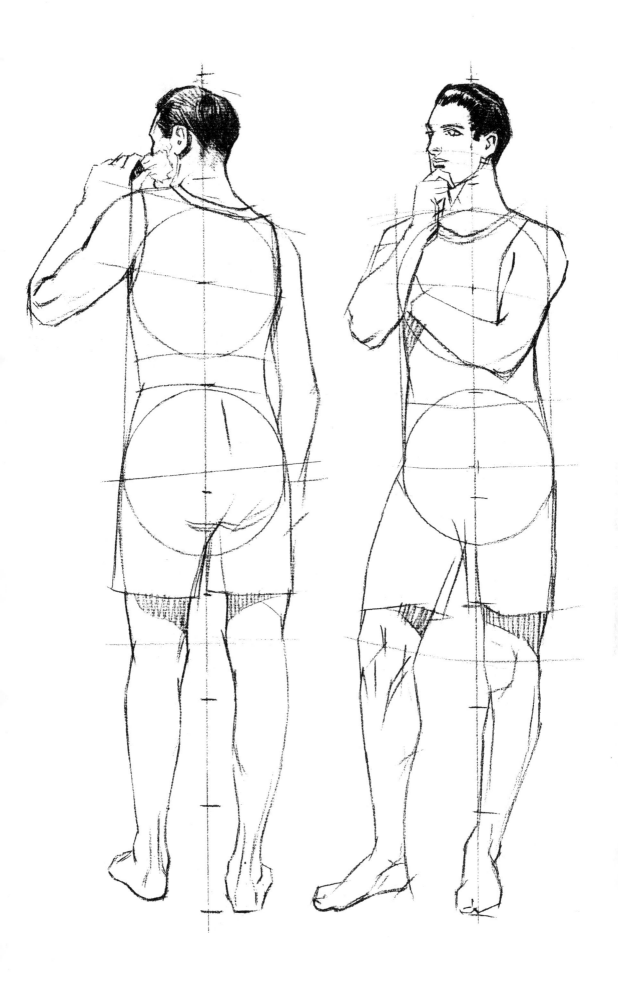

J. C. Leyendecker is making the figures for the House of Kuppenheimer, with broader shoulders, smaller hips and longer bodies; in doing this it makes the heads look too small and it takes a master artist to make them look good.

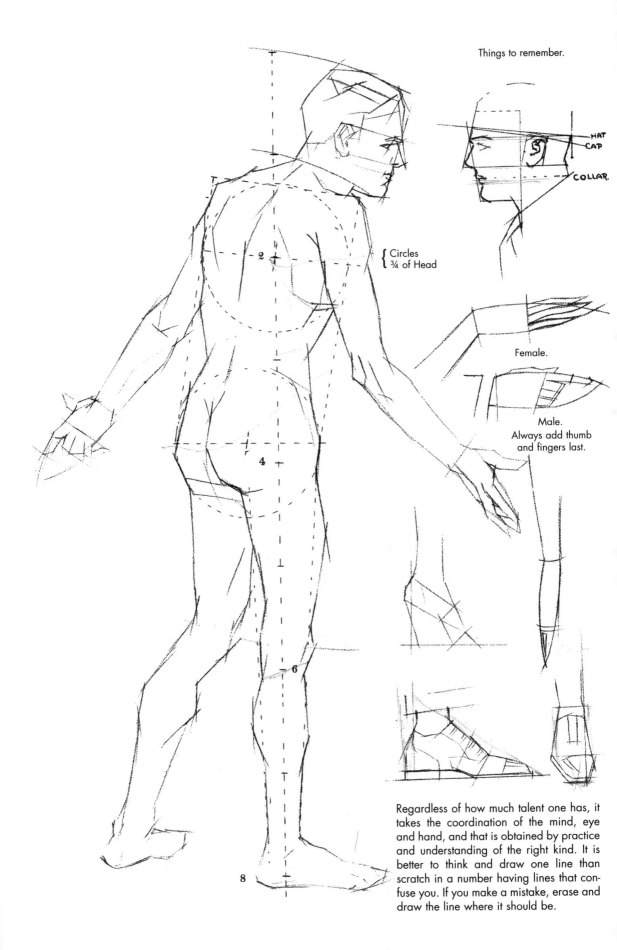

Things to remember.

HAT
CAP
COLLAR.

{ Circles
{ ¾ of Head

2

Female.

Male.
Always add thumb
and fingers last.

4

6

Regardless of how much talent one has, it
takes the coordination of the mind, eye
and hand, and that is obtained by practice
and understanding of the right kind. It is
better to think and draw one line than
scratch in a number having lines that con-
fuse you. If you make a mistake, erase and
draw the line where it should be.

8

Never be discouraged by a spoiled drawing. Profit by it and
make the next one better. Our great artists draw and re-draw
until they have the drawing right, and that is the reason they are
great. In using ink, oils, pastel, watercolor, or opaque, the
blocking in is the same.

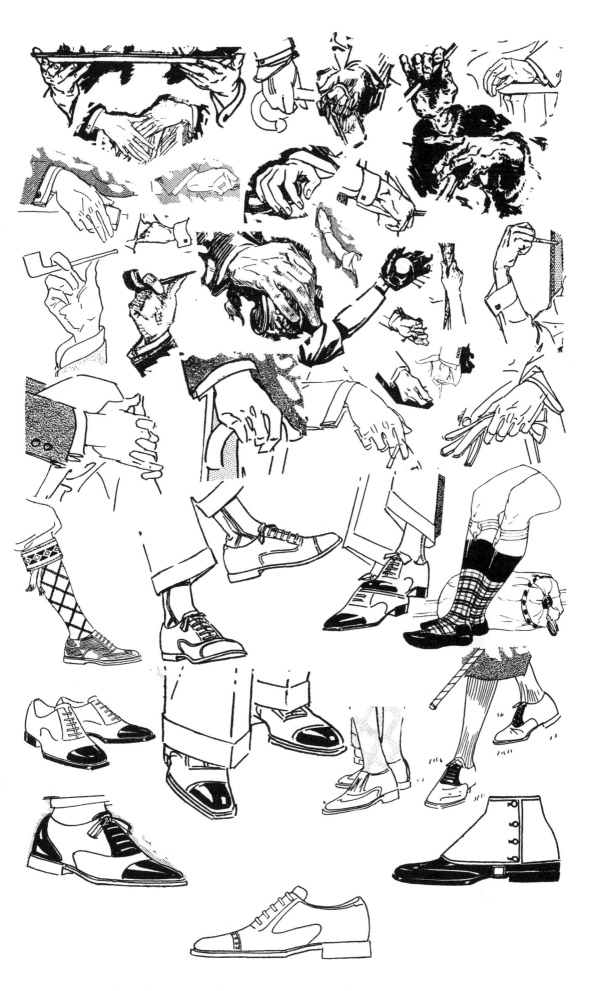

Hands and feet are one of the artists' greatest stumbling blocks. It will be well for you to practice the leaf shape for hands shown in my book "How to Draw the Figure: Female Fashions." Also, feet and hands that are blocked in on other pages of this book.

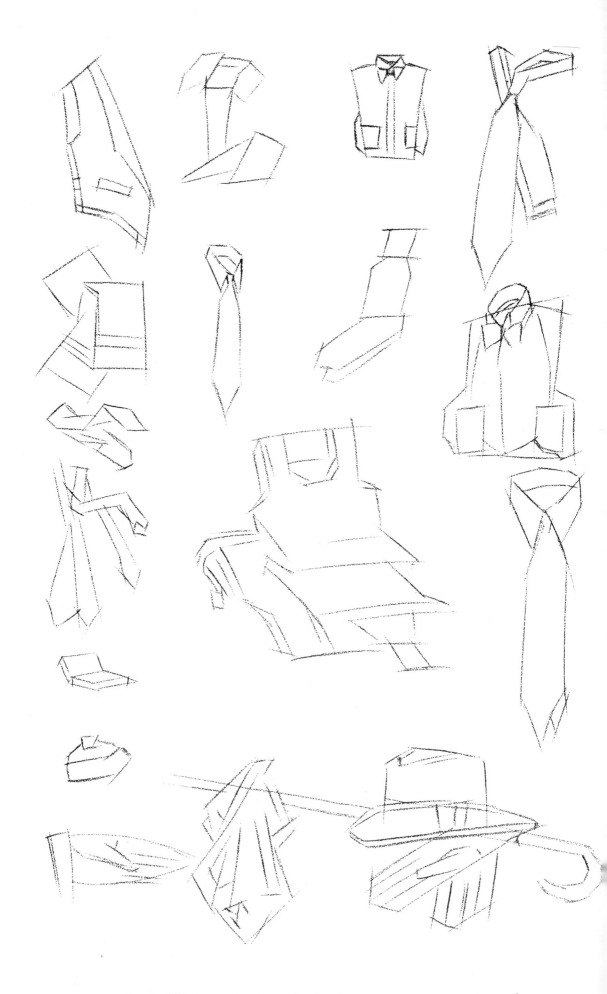

The pencil blocking in (or drawing) is for placement on paper, proportions and formation, and after practicing a lot you will find it is not necessary to make a detailed pencil drawing to ink in over.

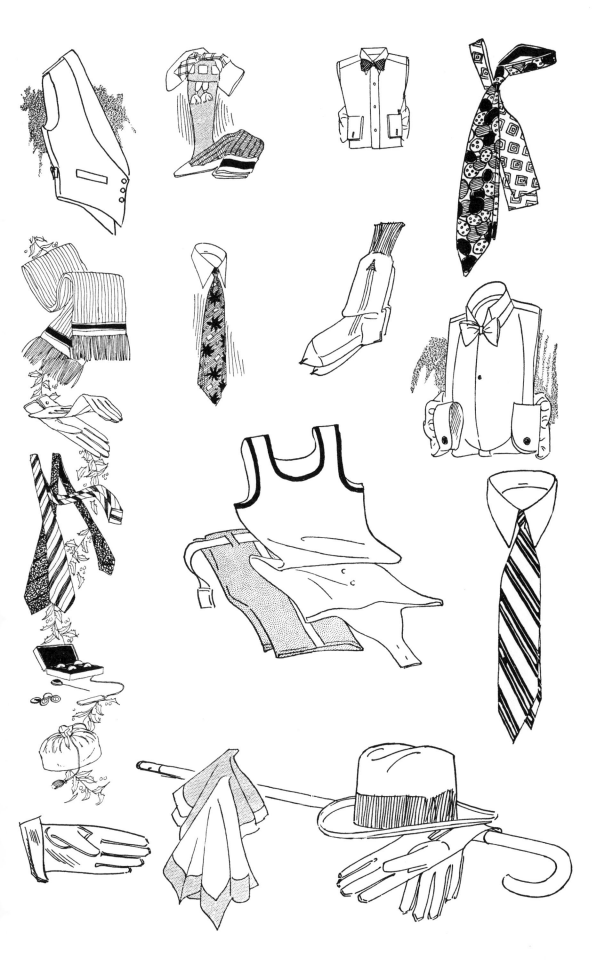

Still life must look new but not give the appearance of being made with a ruler and right line pen.

It is best not to make the detailed pencil drawing but learn to ink in over your blocking in as shown on opposite page.